Antoine Watteau:

101 Paintings and Drawings

By Jessica Findley

First Edition

Antoine Watteau: 101 Paintings and Drawings

Copyright © 2014 by Jessica Findley

Antoine Watteau

Foreword

One of the most brilliant and original artists of the eighteenth century, Antoine Watteau (1684–1721) had an impact on the development of Rococo art in France and throughout Europe lasting well beyond his lifetime. Living only thirty-six years, and plagued by frequent illness, Watteau nonetheless rose from an obscure provincial background to achieve fame in the French capital during the Regency of the duc d'Orléans. His paintings feature figures in aristocratic and theatrical dress in lush imaginary landscapes. Their amorous and wistful encounters create a mood but do not employ narrative in the traditional sense. During Watteau's lifetime, a new term, fête galante, was coined to describe them. Watteau was also a gifted draftsman whose sparkling chalk sheets capture subtle nuances of deportment and expression.

The son of a roofer, Watteau was born in 1684 in Valenciennes, a small city in the north that had only been ceded to France from the Spanish Netherlands six years earlier. Details of his initial training remain obscure, but early biographers concur that shortly upon arriving in the French capital, Watteau was employed in the mass production of crude copies of devotional paintings. Sometime around 1705, he began working for Claude Gillot, who specialized in comic scenes inspired by the commedia dell'arte and who, in turn, introduced him to Claude Audran III (1658–1734), a designer of ornament and interior decoration. Working under these two influential masters, Watteau developed his mature style, increasingly incorporating theatrical subject matter and designs based on the airy arabesques that had begun to dominate interior design.

Despite his unconventional training, Watteau was permitted to compete for the Prix de Rome at the Royal Academy of Painting and Sculpture. He won a second-place prize in 1709, but to his great disappointment was never sent to study in Italy. With the backing of Charles de La Fosse, a fellow admirer of Rubens and Venetian painting, Watteau was accepted into the Academy in 1712. His innovative subject matter did not fit into any established category in the academic hierarchy, and he was ultimately accepted with the unprecedented title "painter of fêtes galantes." His reception piece, Pilgrimage to the Isle of Cythera (Musée du Louvre, Paris), was finally submitted to the Academy in 1717. It depicted amorous couples on the mythical island of Cythera, in various stages of their metaphoric "journey" of love.

Antoine Watteau

With ingenuity and determination, Watteau continued his artistic education by copying works by Rubens and sixteenth-century Italian artists in the collection of Pierre Crozat, a wealthy banker and art collector. Italian Landscape with an Old Woman Holding a Spindle (after Domenico Campagnola) is an example where Watteau carefully transcribed in red chalk the rustic, hilly Italian countryside, adding to his repertoire of motifs that would inspire the backgrounds of his imaginary landscapes. Around the same time Watteau was assiduously making copies from his renowned collection of drawings, Crozat commissioned from him a series of large oval paintings depicting the Four Seasons for his dining room in Paris. Standing Nude Man Holding Bottles is one of a series of studies Watteau made for Autumn, now lost and known only through an engraving.

Another of Watteau's dedicated patrons and friends was Jean de Jullienne, who wrote an early biography of the artist and sponsored an unprecedented campaign to record his drawings as etchings, contributing immeasurably to his fame and influence as a draftsman. His collection included the Mezzetin, a bittersweet depiction of the commedia dell'arte character Mezzetin. He is shown seated and playing music in a garden, his pose evocative of the anguish of unrequited love. In a study for the head, Watteau focused on the figure's plaintive expression. Jullienne also owned The French Comedians, a late canvas likewise inspired by the popular commedia dell'arte theater troupes, although it is unclear whether Watteau meant to portray a specific scene or specific actors.

Admiration for the drawings of Watteau has always been equal to that of his paintings. He drew few compositional studies; for the most part, his graphic oeuvre is made up of chalk studies of heads or figures. In contrast to prevailing practice, Watteau seems usually not to have made figure studies in preparation for predetermined compositions, but apparently filled sketchbooks with incisive renderings of figures drawn from life, which he would later mine for his painted compositions. A drawing of a Seated Woman, for example, has captured all the spontaneity and grace of a young woman's natural movements, yet does not seem to have been used in a painted composition.

Antoine Watteau

Although he limited himself to chalk, there is a clear evolution in the technique of Watteau's drawings. His earliest studies are in red chalk alone, with black chalk eventually added to the red, as in Savoyarde. Around 1715, he added white chalk to the mix. Although Watteau did not invent the technique of trois crayons, or three chalks (Rubens and La Fosse, among others, had used it before him), his name is always linked to the technique for his intuitive mastery of it, melding red, black, and white to great painterly and coloristic effect. In Standing Nude Man Holding Bottles, the three colors of chalk, in combination with the tone of the paper reserve, create a convincing rendering of flesh tones.

Watteau drew because he loved to draw. Sketching constantly, with application and curiosity, was the way he came to understand the world around him. Although he developed great expertise in depicting them, Watteau also looked beneath social frivolities. This was partly a result of his personal isolation. Watteau was careless in matters of material technique and many of his paintings are in consequence in a poor state of preservation.

Sickly and tubercular, the artist died at 37 – always having lived alone or with friends. Even as he struggled with his failing health, his savings vanished with the crash of the French Royal Bank.

In spite of his difficult temperament, Watteau had many loyal supporters who recognized his genius, and although his reputation suffered with the Revolution and the growth of Neoclassicism, he always had distinguished admirers. It is perhaps as a colourist that he has had the most profound influence. His method of juxtaposing flecks of colour on the canvas was carried further by Delacroix and later reduced to a science by Seurat and the Neo-Impressionists. Watteau's principal, but much inferior, followers were Lancret and Pater.

Antoine Watteau

Drawings and Paintings

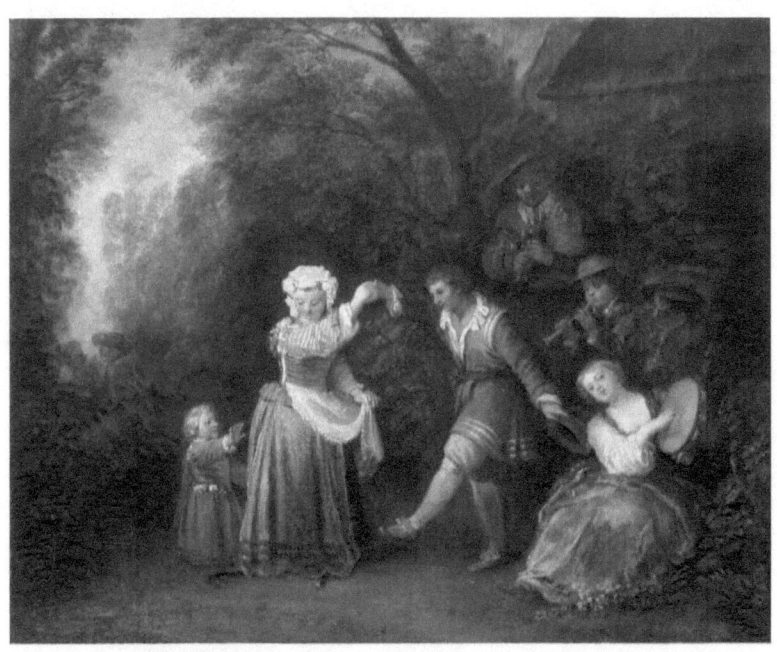

The Country Dance
1706-10, Oil on canvas, 50 x 60 cm

This is Watteau's earliest known painting the subject of which recalls the peasant weddings, country dances, and fairs depicted by Flemish painters like Bruegel and Rubens. However, Watteau treated this northern European subject in a Venetian style.

Jessica Findley

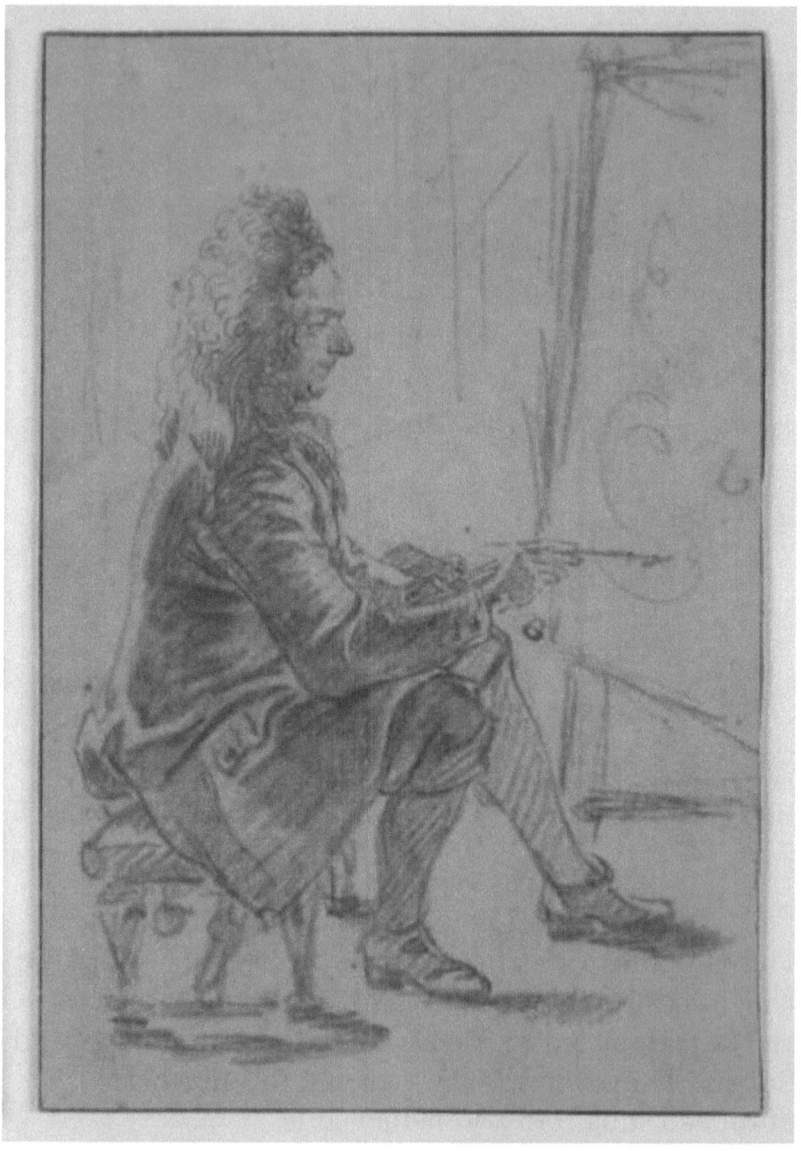

A Bewigged Painter (Possibly Claude Audran), Seated at his Easel, Seen in Profile, 1709, Red chalk on buff laid paper, laid down on cream laid card, 201 x 134 mm, Art Institute of Chicago

Antoine Watteau

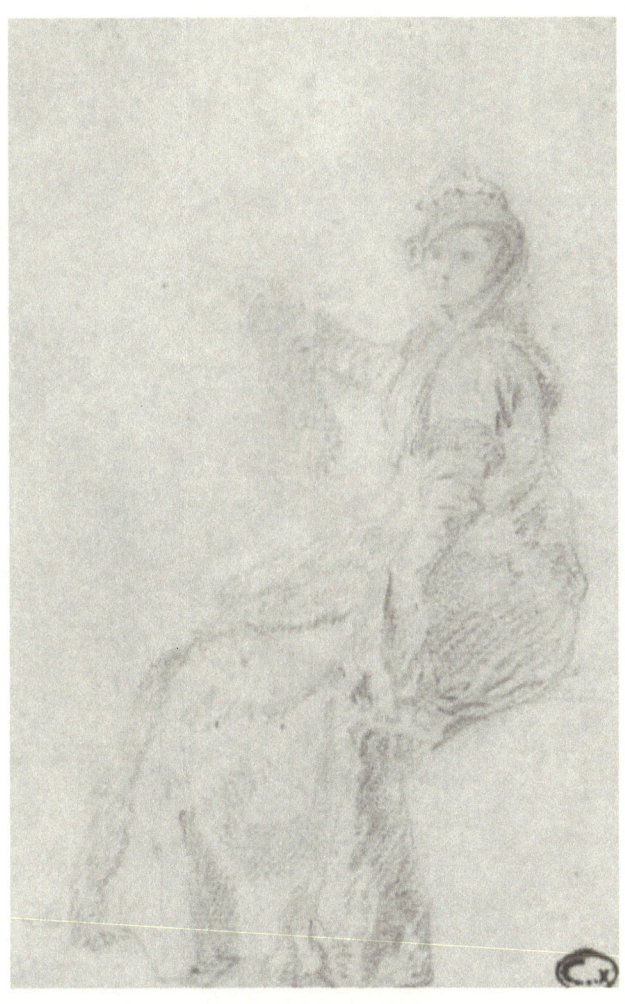

A young woman in a Polonais costume, seated and turned to the left
1709-10, Red chalk, 127 x 83 mm, Private Collection
The figure is similar to one in a painting by Watteau, La Polonaise, apparently lost but known through an engraving from the Recueil Jullienne. Four other drawings depicting women in 'polonais' costumes, all dating circa 1709-10, are known.

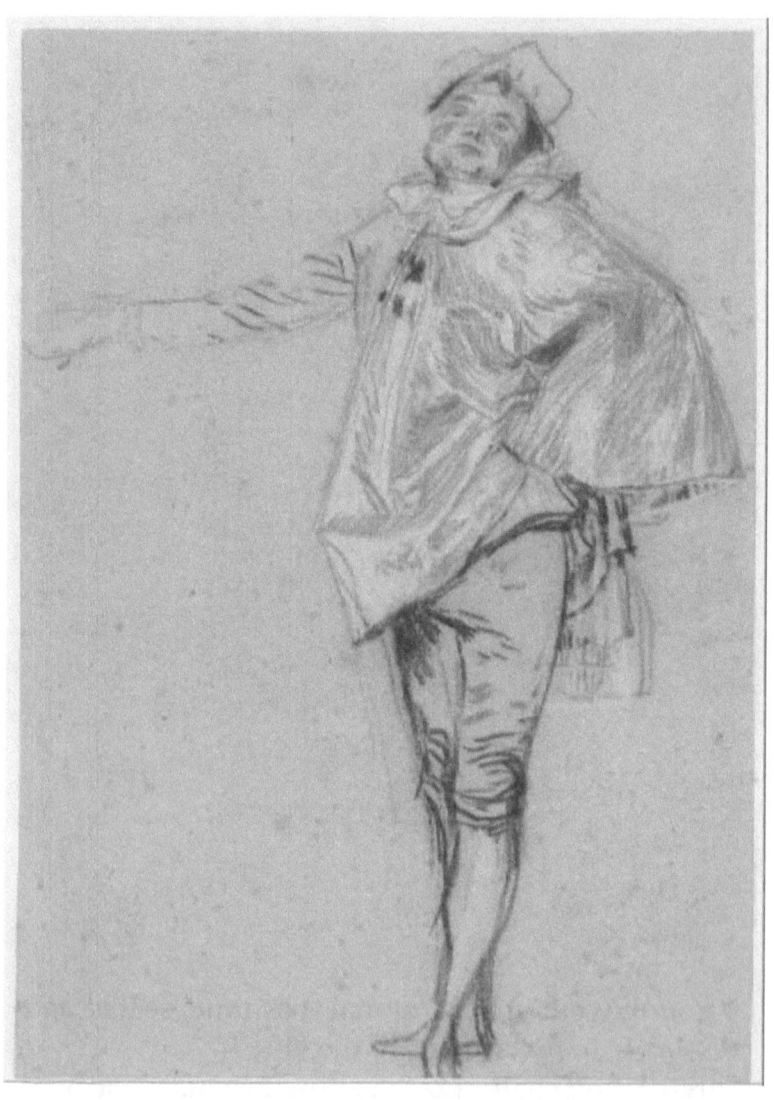

Study of a Standing Dancer with an Outstretched Arm
1710, Black, red, and white chalk, 272 x 189 mm,
Museum Boijmans Van Beuningen

Antoine Watteau

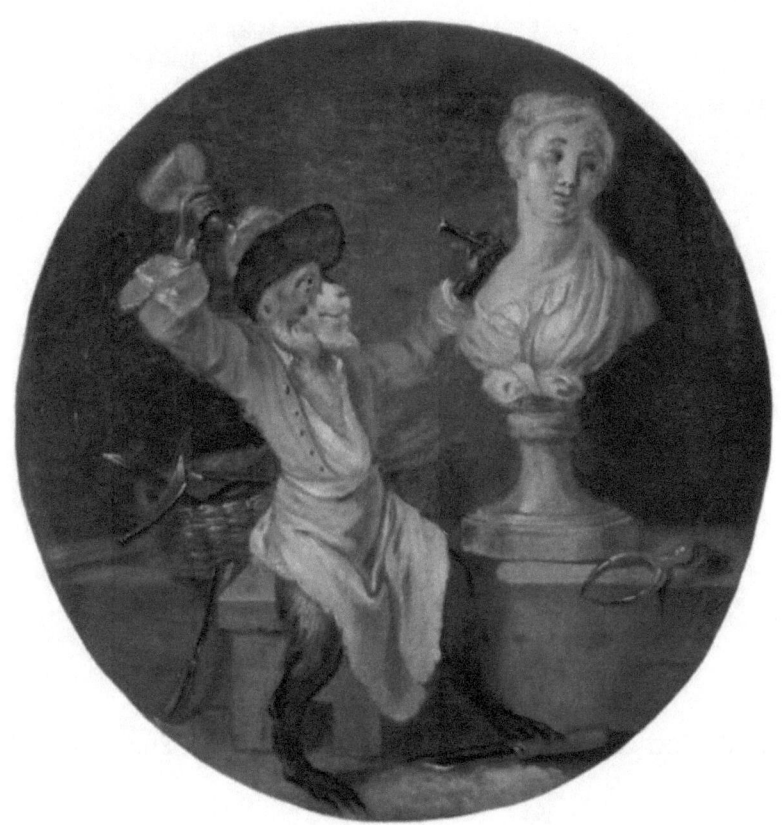

The Monkey Sculptor
1710, oil on canvas

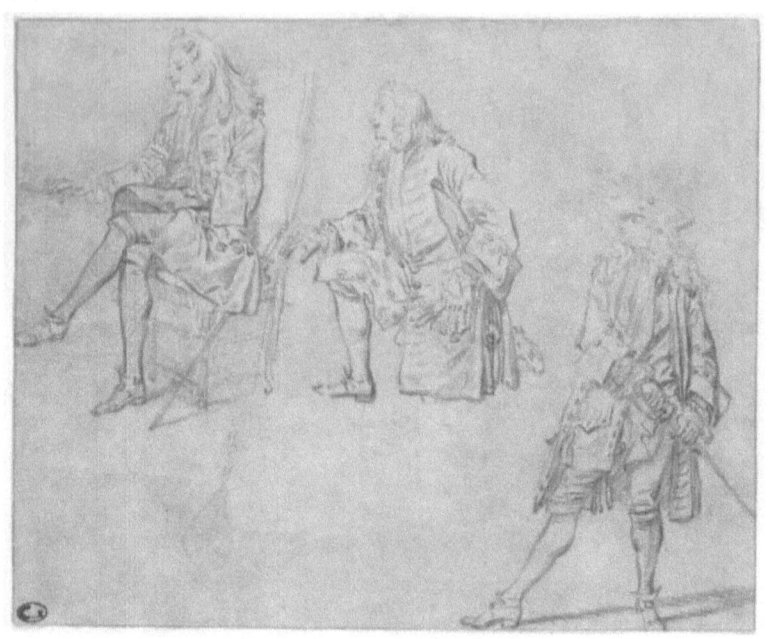

Three Studies of a Gentleman
1710, Red chalk, on ivory laid paper, 166 x 202 mm Art Institute of Chicago

Antoine Watteau

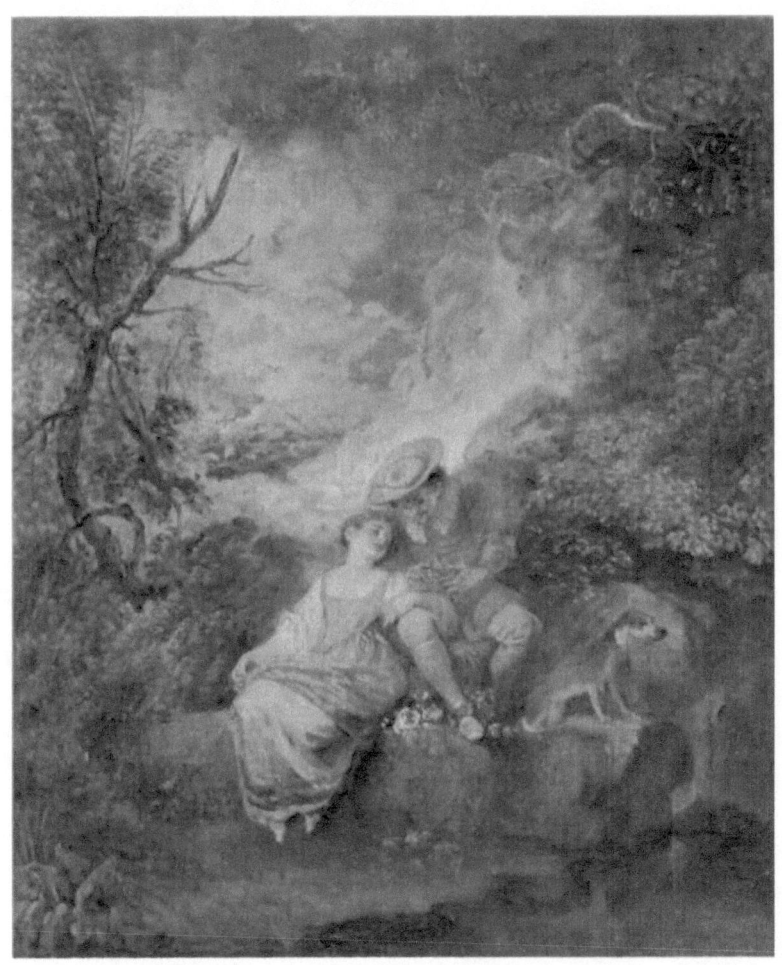

The Bird Nester
1710, oil on canvas

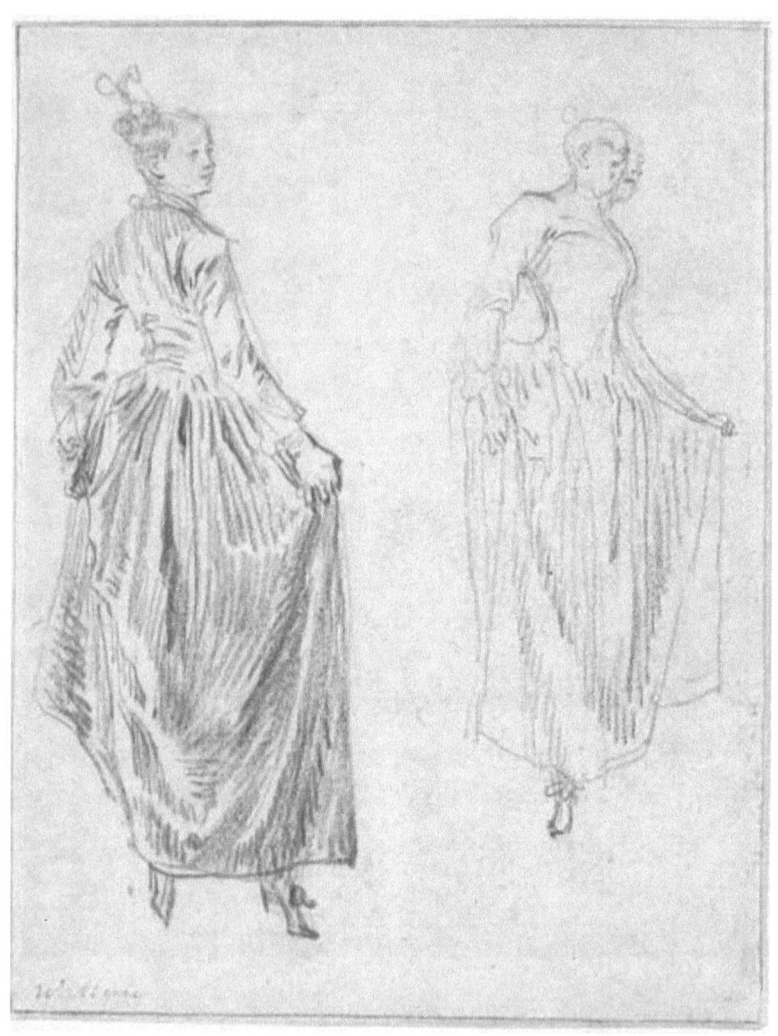

Two Studies of a Dancer Raising Her Skirt in Her Two Hands,
1712–13, Red chalk on cream laid paper, 176 x 133 mm,
Art Institute of Chicago

Antoine Watteau

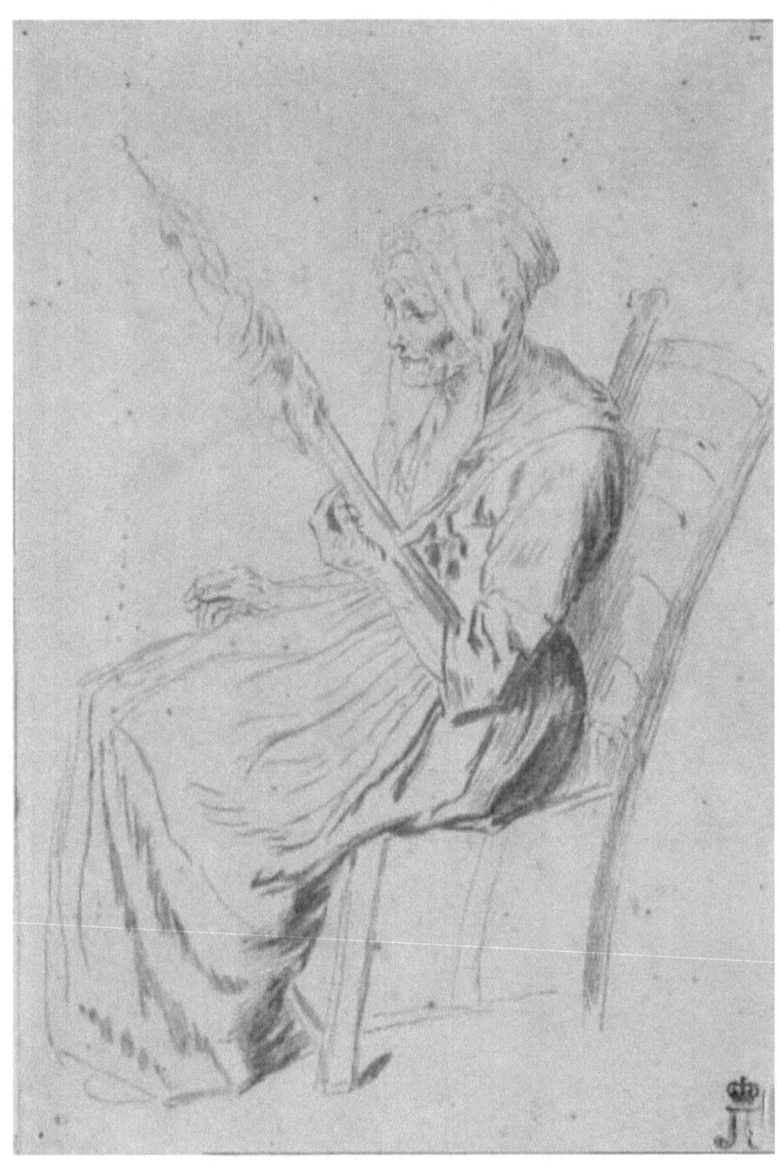

Old Woman with a Distaff
1710s, Black and red chalk on brown paper, 285 × 193 mm, Hermitage Museum

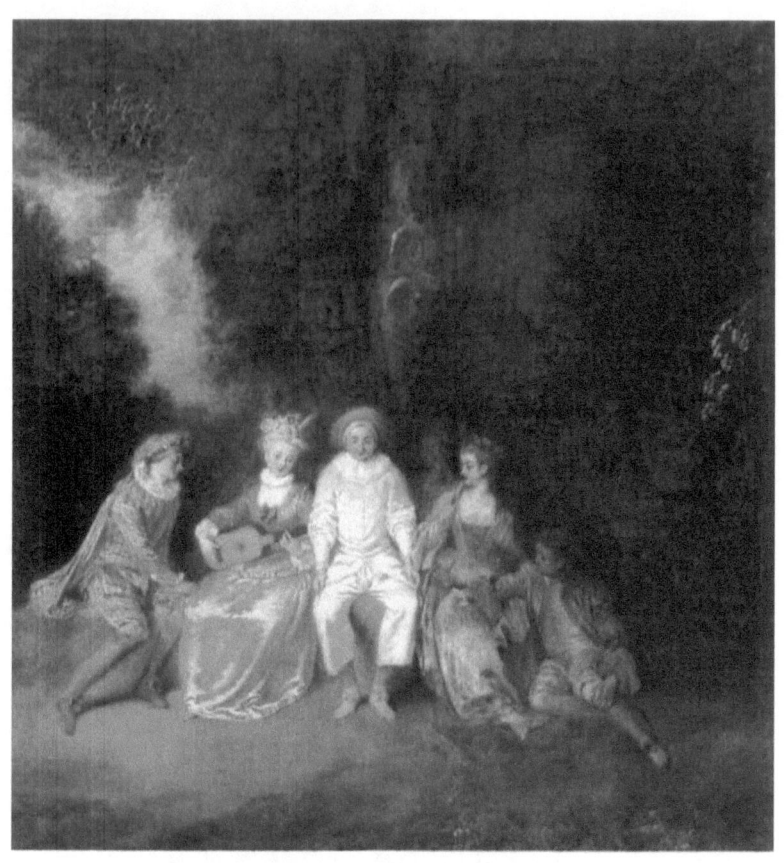

Pierrot Content
c. 1712, Oil on canvas, 35 x 31 cm

Antoine Watteau

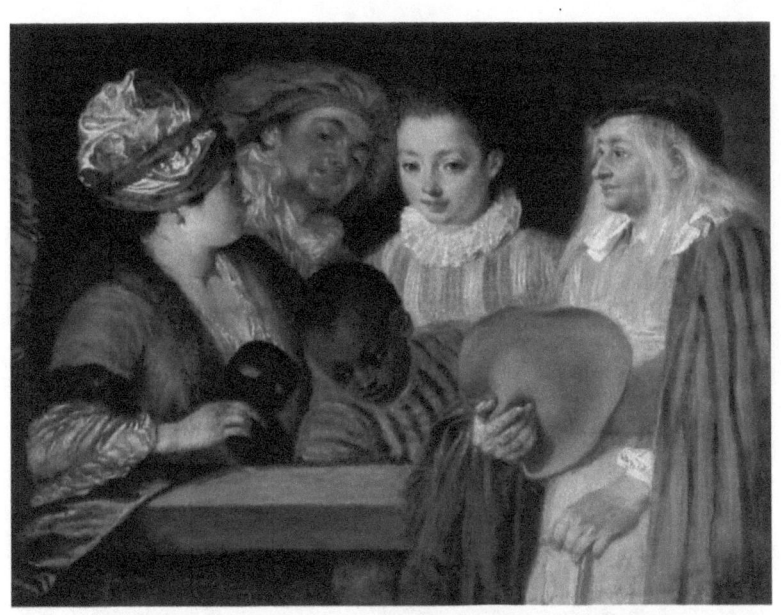

Actors of the Comedie-Francaise
c. 1712, Oil on panel, 20 x 25 cm

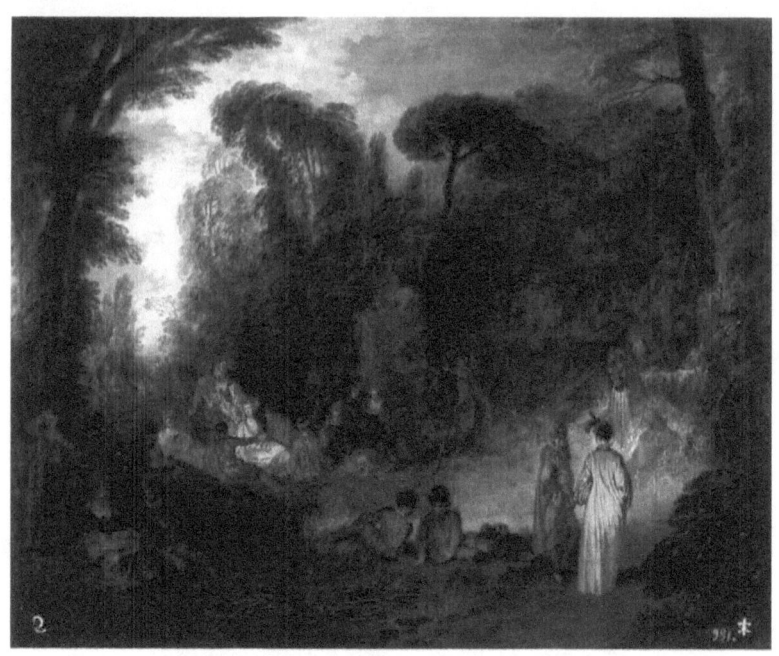

Gathering in a Park
1712-13, Oil on canvas, 48 x 56 cm

Antoine Watteau

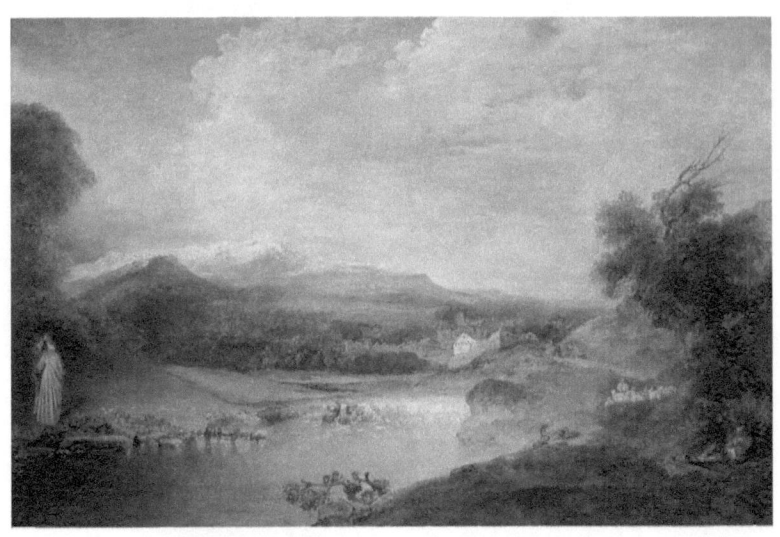

Landscape with a Waterfall
1714, Oil on canvas. 72x106 cm

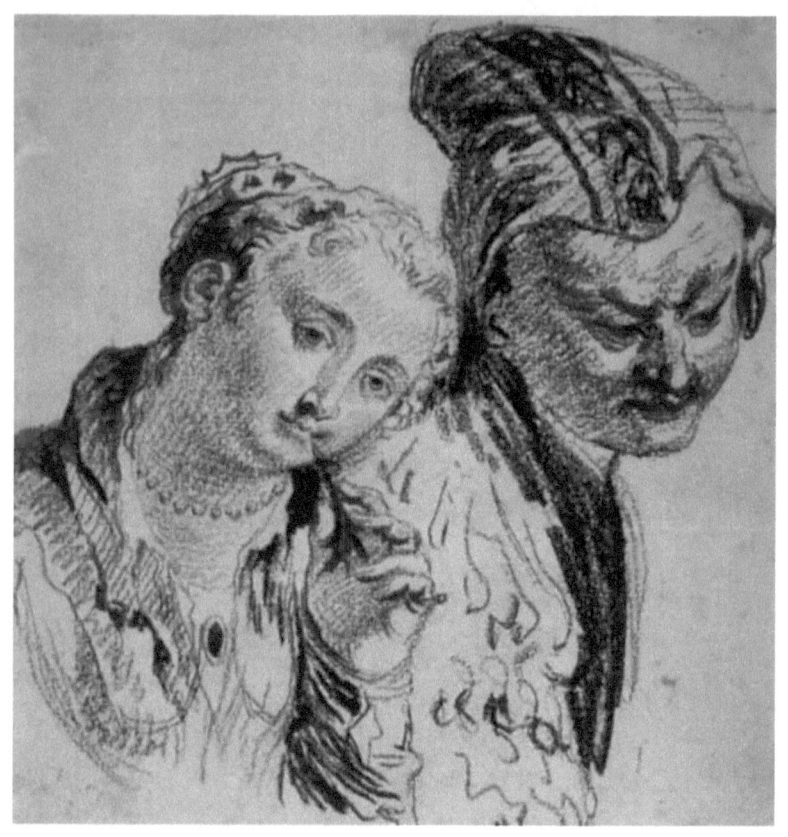

Sketch with Two Figures
1710-15, Red and black chalk, 196 x 184 mm,
Ashmolean Museum, Oxford

The blond Venetian woman on the left section of the table is using an ornate fork as a toothpick. For centuries, the figure caught the imagination of later painters, from Rubens to Watteau. In 1590, the Milanese painter and art writer Giovanni Paolo Lomazzo (1538-1600) used the example of this figure to highlight the Venetian painters' ability to give expression to various emotions and psychological states in the figures.

Antoine Watteau

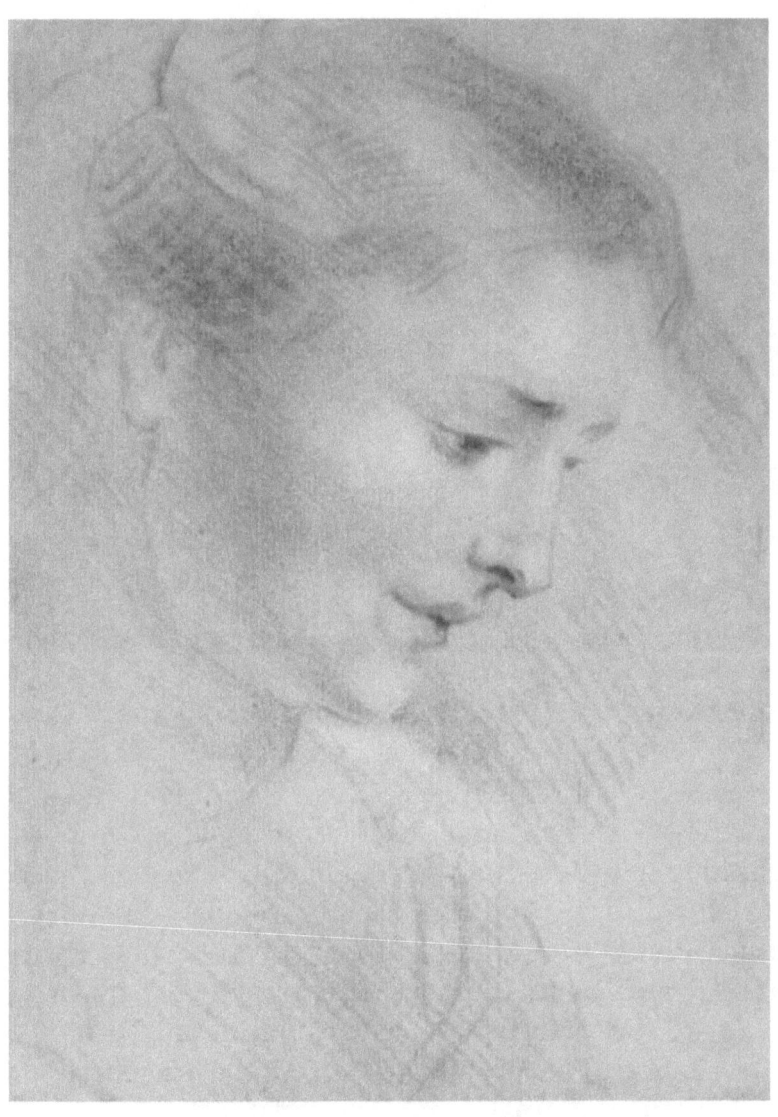

Study of a Woman's Head
1710s, Black, white and red chalk on light brown paper,
330 x 230 mm, The Hermitage, St. Petersburg

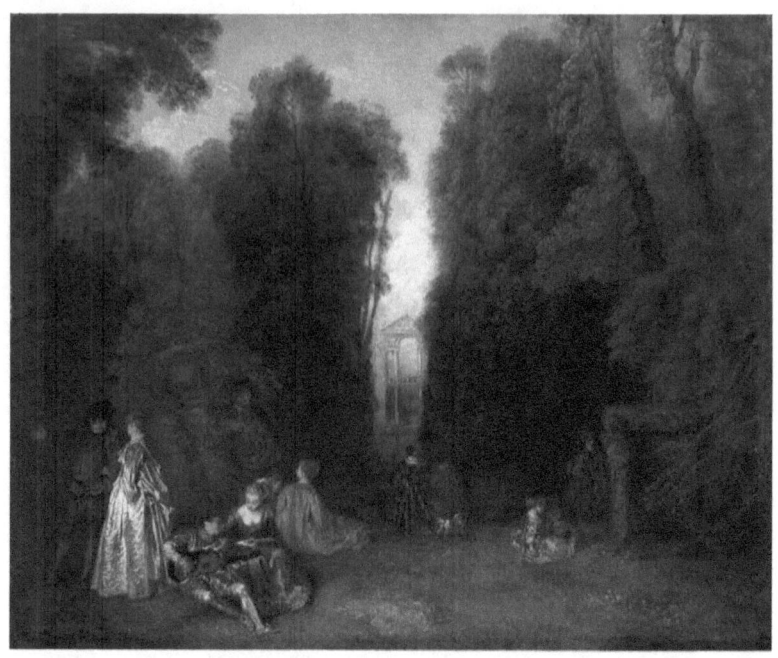

La Perspective (View through the Trees in the Park of Pierre Crozat)

c. 1715, Oil on canvas, 47 x 55 cm

Watteau developed and made famous a type of painting of the elegant party, called the fête galante, in which ladies and gentlemen converse, flirt, and make music in idyllic outdoor settings. This is his only fête galante with an identifiable setting: in the distance, Watteau shows the Château de Montmorency near Paris, home of his friend and patron, the art collector and financier Pierre Crozat. The artist freely transformed the site, creating a dreamlike fantasy world evocative of the theater with its backdrop of towering trees and graceful groupings of figures in old-fashioned dress.

Antoine Watteau

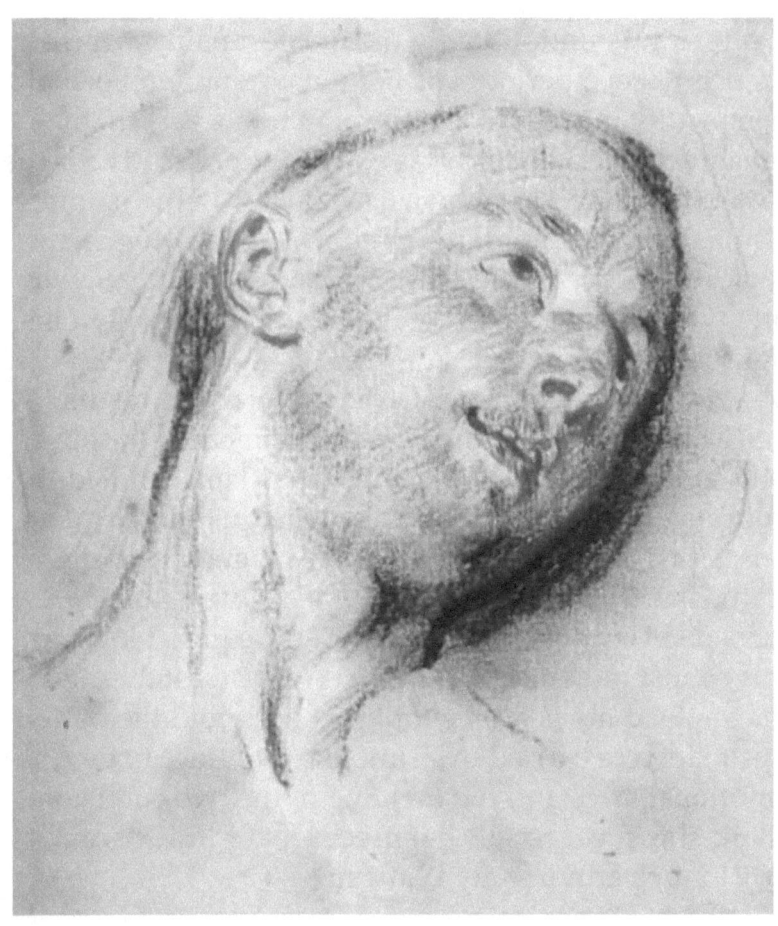

Head of a Man
1715, Red and black chalk, 14, 9 x 13 cm, Metropolitan
Museum of Art, New York

Watteau was undoubtedly the greatest painter of the French Rococo period. His poignancy and intellectual perspicuity made him unique among his peers. This sensitively modeled head is a preparatory study for the seated figure of Mezzetin as he appears in the painting also in the Metropolitan Museum. The drawing is a typical example of the draftsmanship of Watteau, who often used a combination of red and black chalk in his figure studies.

Mezzetin was a character in the popular commedia dell'arte, typically amorous and sentimental. In the Museum's painting, he sits on a stone bench outside a building, playing a guitar and gazing plaintively at an unseen window. The artist placed a female garden statue in the woods behind the Mezzetin, its back turned to the actor, suggesting an unrequited love. In this robust red and black study, Watteau established the angle of the head, the uplifted eyes, and the parted lips that were carried over into the painting. In its emotional force and the melding of the two colors of chalk, this sheet recalls the precedent of Rubens, an artist much admired by Watteau.

Antoine Watteau

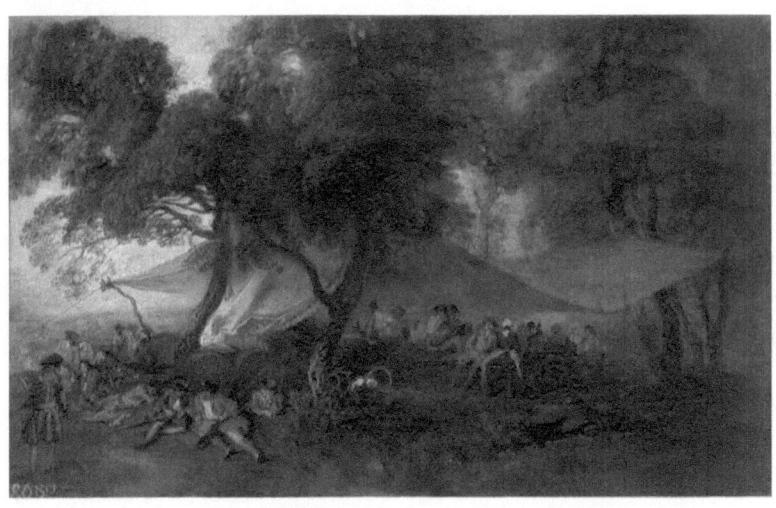

Idylls of War, Pair to the painting "The Hardships of War"
1715, Oil on copperplate, 21.5x33.5 cm

Hardships of War, Pair to the painting "The Idylls of War"
1715, Oil on copperplate, 21.5x33.5 cm

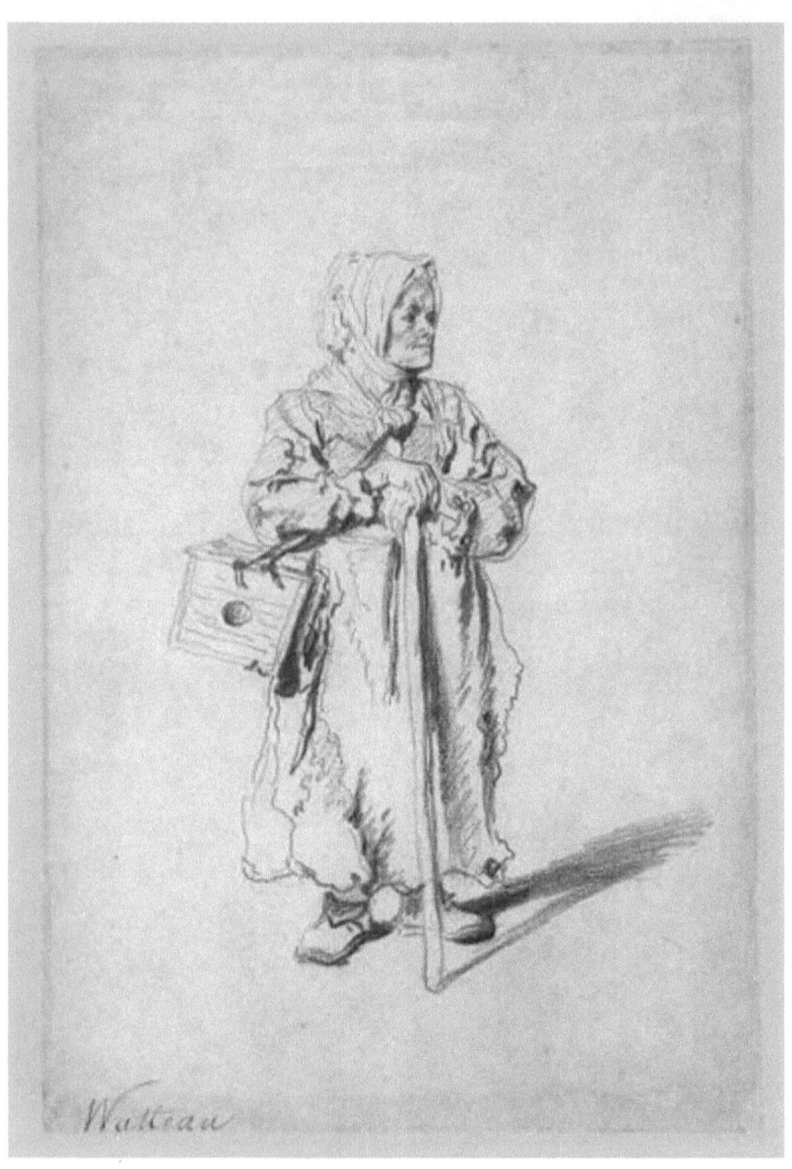

Savoyarde
1715, Red and black chalk, 31.2 x 20.3 cm, The Metropolitan Museum of Art

Antoine Watteau

Early in his career, before devoting himself to popular subjects of lovers, aristocrats, and commedia dell'arte figures, Watteau treated themes inspired by his Northern training: the hardships of military life and the travails of the lower classes. This sheet is one of around a dozen depicting Savoyards, natives of the region of Savoy, whose impoverished circumstances sometimes led them to take up an itinerant life as street performers. This elderly woman in ragged clothes leans on a cane and gazes off to the side. On her arm is strapped a box to hold a marmot, used as a form of street entertainment. Watteau records her with candor, first in red chalk, and then with sharp accents of black to pick out creases and shadows.

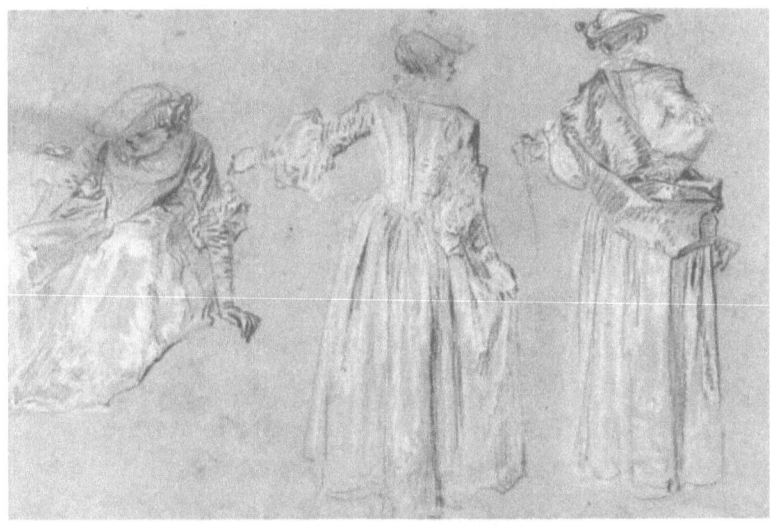

Three Studies of a Lady with a Hat
1715, Chalk on paper, 210 x 313 mm, Musees Royaux des Beaux-Arts, Brussels

Jean Antoine Watteau was the interpreter par excellence of the carefree, at times somewhat melancholy dream-world that is characteristic of the Rococo period. At the age of 18 he left his native city of Valenciennes and travelled to Paris, where he quickly made his name with paintings of military and country scиnes. In 1717 he became a member of the Acadйmie Royale as the creator of fêtes galantes - romantic gatherings - often with musical accompaniment - of fashionably dressed lovers. It was with this new genre that Watteau achieved his international breakthrough. The key to Watteau's work is the drawing: he was constantly sketching and would catch friends and acquaintances again and again in real-life attitudes, which were swiftly committed to paper. Professional models, too, came to pose for him in endlessly changing costumes. Often he would draw the same figure several times on a single sheet, each time under a changing light. These drawings were then scrupulously conserved in large, bound volumes, which later served for composing paintings. For example, the gracious female figure to the right of the page discussed here appears in the Peasant Marriage, probably painted in 1715. Already in this early phase of creation Watteau made masterly use of two types of chalk: the figures are built up with soft red chalk lines, with white chalk highlights suggesting patches of light. Particular attention was paid to the decorative treatment of the garments, the folds and texture of which he sought to reproduce as close to nature as possible.

Antoine Watteau

He was constantly perfecting his technique, from 1715/16 onwards even drawing "aux trois crayons". This combined use of black, red and white chalk goes back to the 16th century Italian masters, including Federico Zuccaro. It was applied brilliantly by Peter Paul Rubens, from whom Watteau learned much. Contrary to the great baroque master's powerful language of shapes, Watteau produces a fragile modelling evoked by gossamer-thin lines and short strokes that resonate nervously on the surface of the paper. These confer a particularly refined elegance to his graceful female figures - one represented sitting, the other two standing in elegant dance positions.

Design of the Decorative Panel: Autumn
1715, Red chalk, 28x18.6 cm, Hermitage Museum

Antoine Watteau

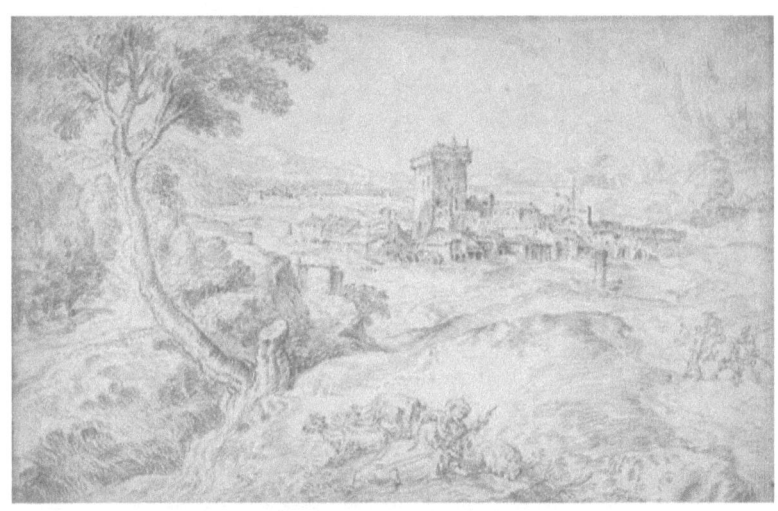

Italian Landscape with an Old Woman Holding a Spindle (after Domenico Campagnola)
1715, Red chalk, 20.5 x 31.8 cm, The Metropolitan Museum of Art

A wealthy banker, Pierre Crozat was one of the foremost collectors of drawings in the eighteenth century. He befriended Watteau, offering him commissions, housing, and access to his collection. Watteau was entranced with the sixteenth-century Venetian landscape drawings he found there and copied many of them. In this case, the original drawing by Domenico Campagnola (1500–1564) is also in the collection of the Museum (1972.118.243). Although he is faithful to Campagnola's composition, Watteau substituted his preferred medium, red chalk, for the Venetian's pen and brown ink.

Jessica Findley

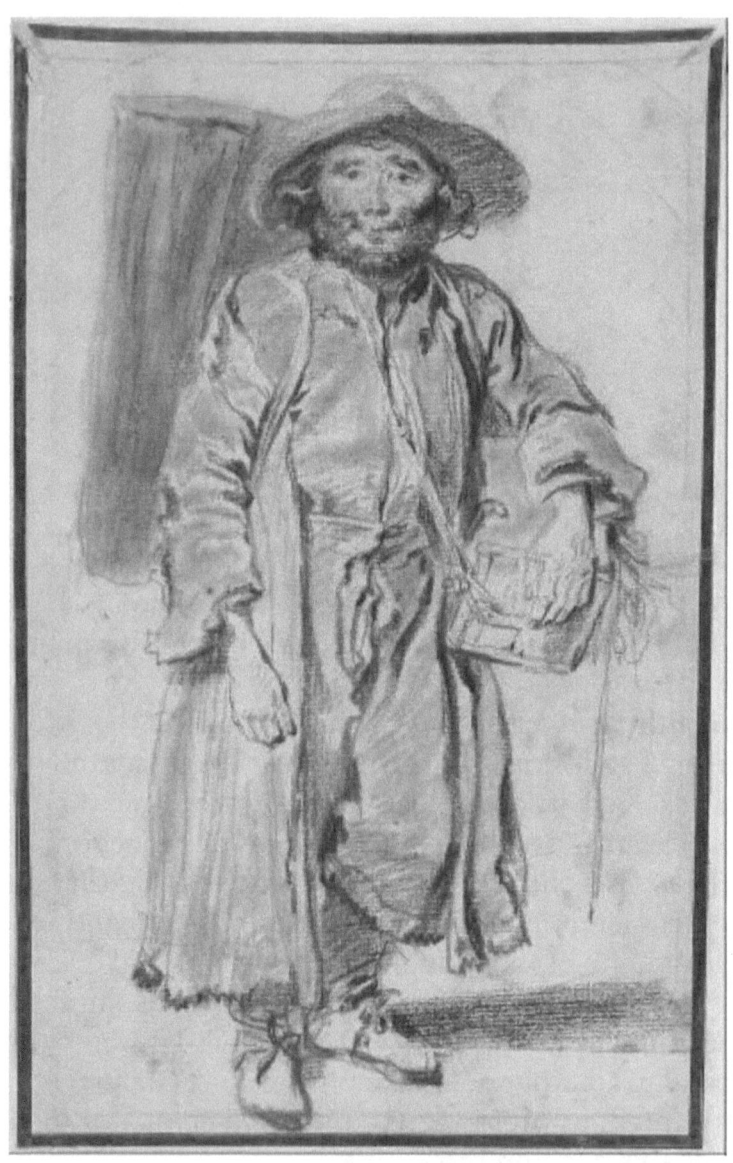

The Old Savoyard
1715, Red and black chalk, with stumping, on buff laid paper, laid down on cream wove card, laid down on cream board, 359 x 221 mm, Art Institute of Chicago

Antoine Watteau

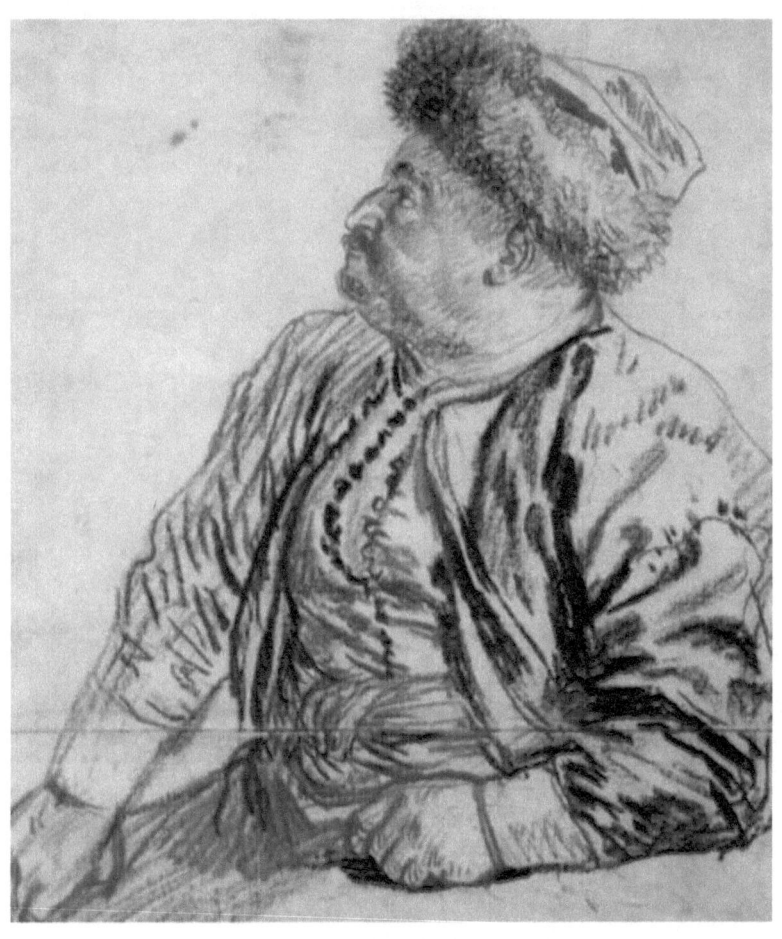

Seated Persian
1715, sanguine and black chalk on cream paper, 25 × 21.2 cm
Drawing is part of a series of portraits of a Turkish delegation which visited 1715 in Paris.

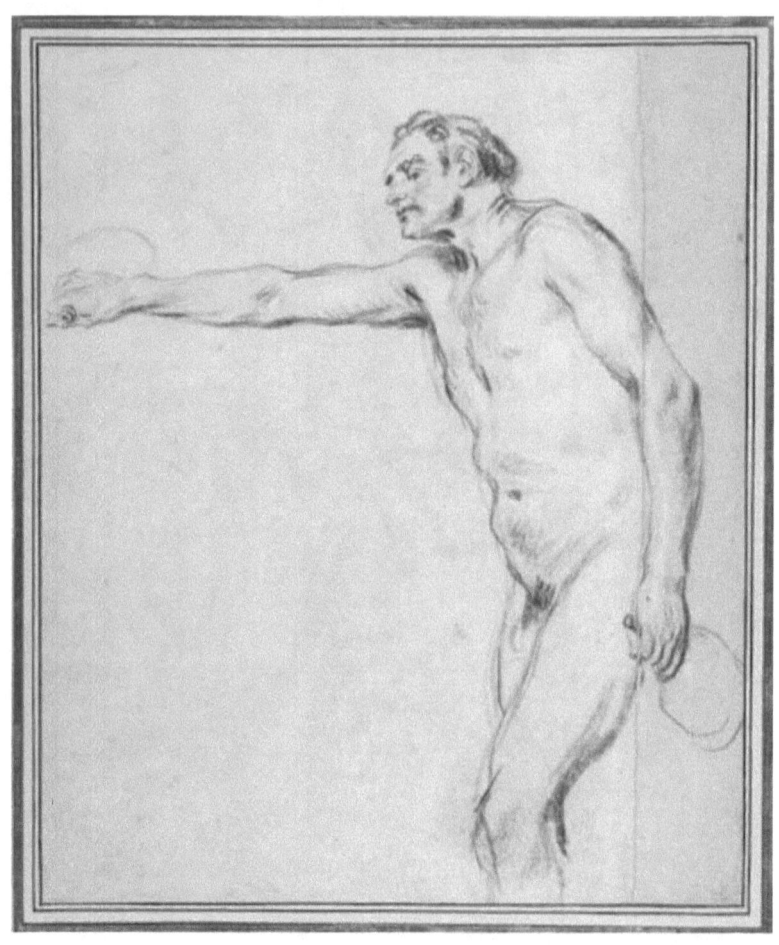

Standing Nude Man Holding Bottles
1715–16, Red, black, and white chalk, The Metropolitan Museum of Art

Antoine Watteau

The four large oval paintings of the Seasons commissioned by Pierre Crozat (1665–1740) for his Paris dining room constitute rare examples of mythological subjects in Watteau's oeuvre. The painting Autumn, known today only through engravings, depicted a standing satyr pouring wine for a seated Bacchus. This sheet is one of two known studies (the other is in the Courtauld Institute Galleries, London) for the figure of the standing satyr. The New York drawing must have been the earliest, made before Watteau decided to bend the satyr's pouring arm to better suit the oval format. Red, black, and white chalk is intuitively combined to produce the appropriately ruddy flesh tones of the satyr.

Jessica Findley

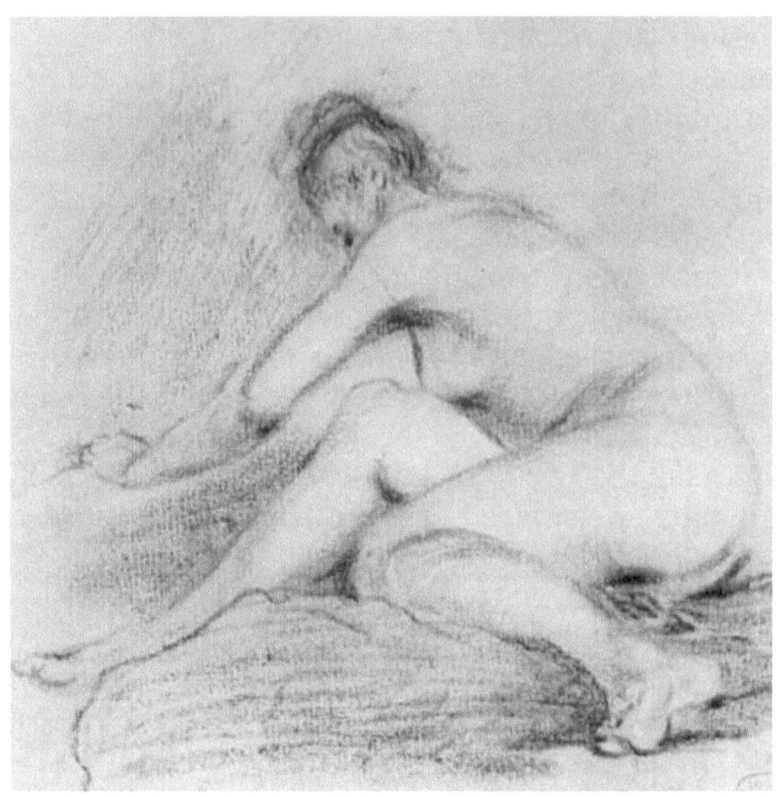

Reclining Woman
1715-1716, sanguine and black chalk, heightened with white, on beige paper, 23.2 × 23 cm, Lille Palais Beaux Arts

Antoine Watteau

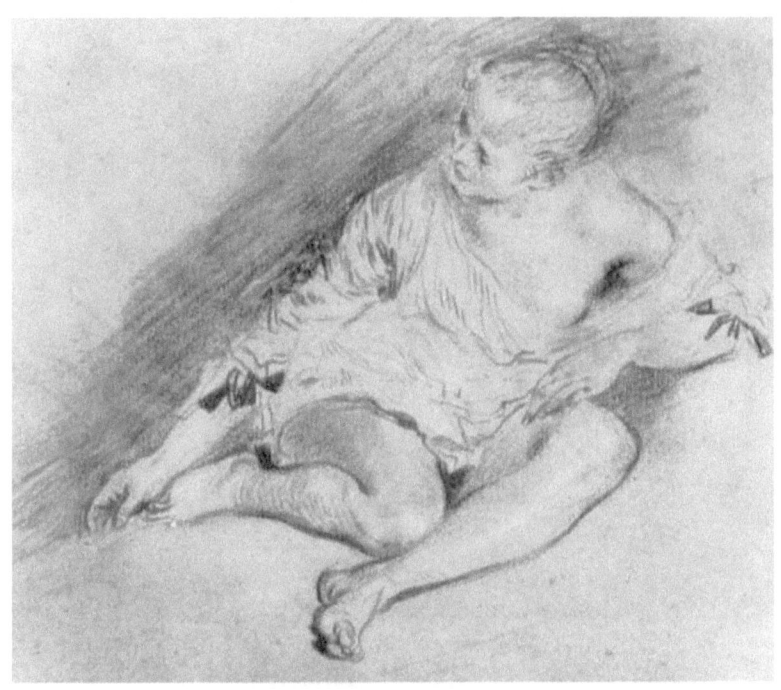

Sitting young woman with shirt
1716, Black chalk, red chalk and white chalk, on light beige paper, 17.4 × 20.6 cm

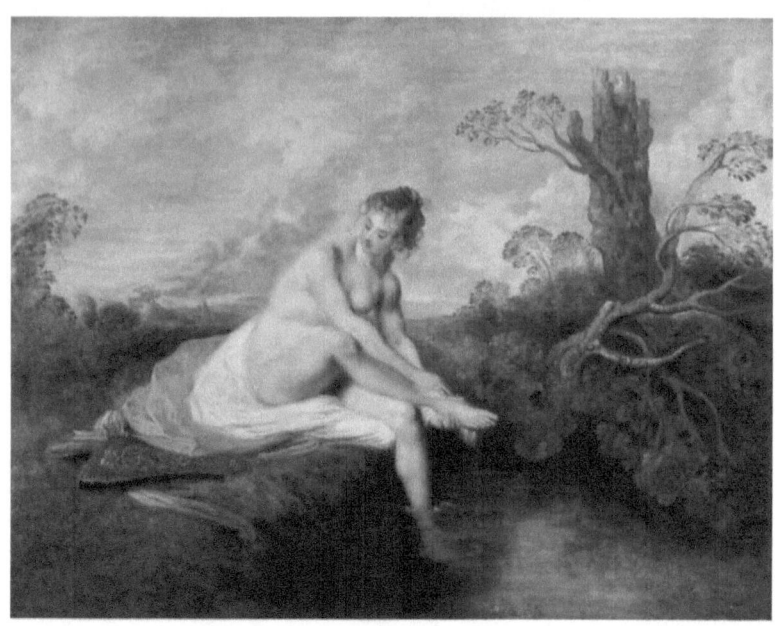

Diana at her Bath
1715-16, Oil on canvas, 80 x 101 cm

Antoine Watteau

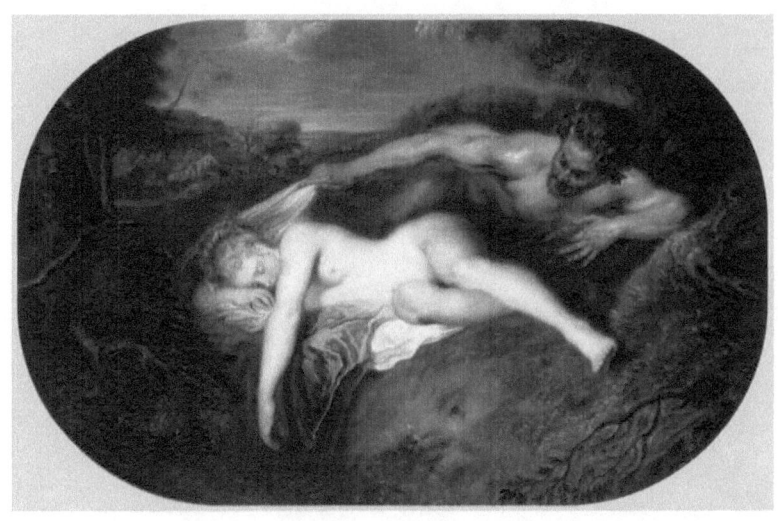

Jupiter and Antiope
1715-16, Oil on canvas, 73 x 107 cm (oval)

This painting, also known as Nymph and Satyr, is one of the most sensual works by Watteau. The subject is taken from Greek mythology (Ovid, Metamorphoses). Antiope was a nymph or, according to some, the wife of a king of Thebes. She was surprised by Jupiter in the form of a Satyr while she was asleep, and was ravished by him. The theme was used at different art periods as a medium for portrayal of the female nude.

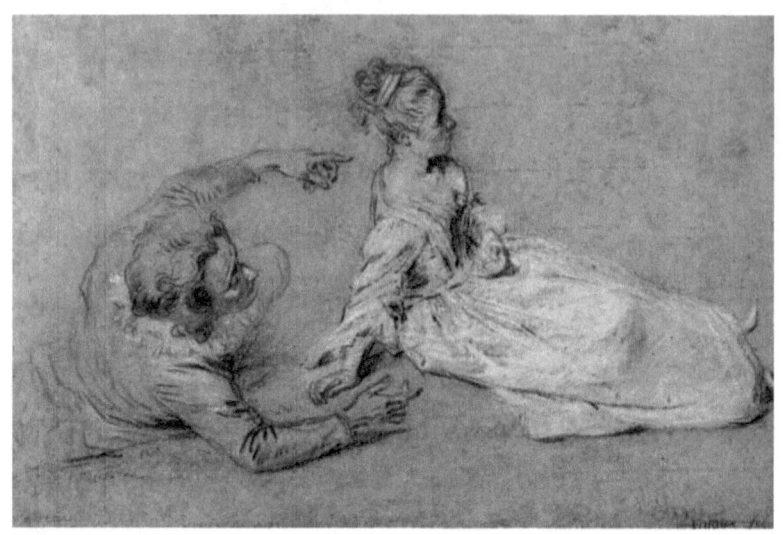

Sitting Couple
1716, Red, black and white chalk on brownish paper, 241 x 349 mm, Armand Hammer Collection, Los Angeles

Watteau was a master of the technique called 'aux trois crayons' ('with three chalks'), which means a drawing in black, red and white chalks, often carried out on tinted paper. The technique was applied in the early part of the 18th century.

Antoine Watteau

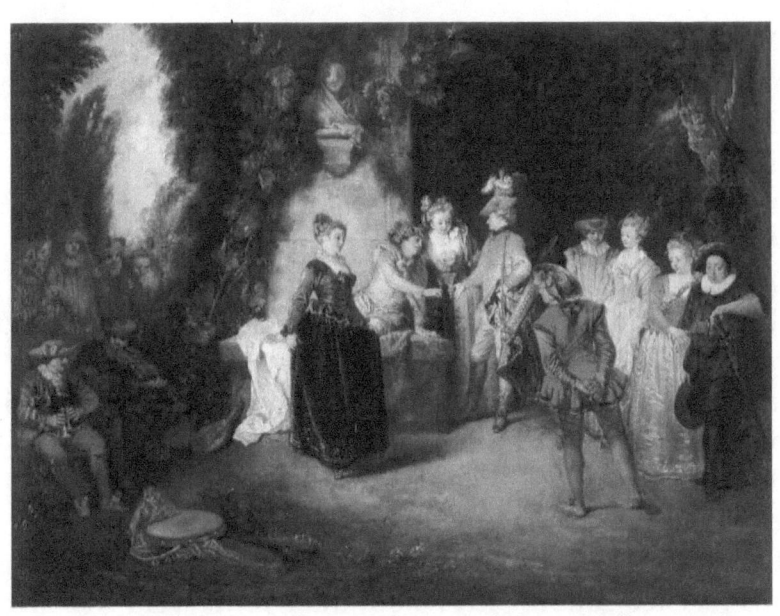

The French Comedy
c. 1716, Oil on canvas, 37 x 48 cm

In 1734 the French Comedy and the Italian Comedy were reproduced as copper engravings by C. N. Cochin. He named them respectively 'L'Amour au thñâtre franзais' and 'L'Amour au thñâtre italien', thus making the artist's intentions clear.

A shepherd and shepherdess in a park, surrounded by a company of people, form the focal point of the French Comedy. Bacchus is reclining on a stone bench, drinking to a huntsman, while musicians provide music for the dance. One must not assume that Watteau had any particular play in mind; he was probably aiming to portray the various characters of the Comedy. This does not mean that he never depicted real people or happenings; at all events he will have taken for granted that the observer or his patron would be able to recognize such details. The gentleman in black on the right is in all probability the well-known actor Paul Poisson.

The theatre plays an important part in Watteau's art. His teacher Gillot, with whom the twenty-year-old Flemish-born painter began his work in Paris, appears to have encouraged this interest in the theatre. Watteau's most famous portrait, the Gilles in the Louvre, is the portrayal of a stage character. Stage-play and reality are strangely interwoven, as they are also in his pictures of social occasions, the fêtes galantes, which Watteau originated and executed with such artistry. These gained for him recognition by the French Academy.

Antoine Watteau

There is documentary evidence to show that, from 1769 onwards, this painting and its counterpart, the Italian Comedy, were in the picture gallery at Sanssouci, having previously formed part of the Henri de Rosnel Collection. The founders of the Berlin Museum, however, steeped as they were in the tradition of Goethe and Winckelmann, had no time for Watteau's art, despising its frivolity. The outstanding collection of the works of French painters that Frederick the Great had built up in Potsdam remained almost untouched when pictures were selected for the Berlin Gallery in 1830. Only two paintings by Watteau, which happened to be the smallest, met with the Commission's approval and were accepted for the Museum: The French Comedy and The Italian Comedy. The Enseigne de Gersaint, at that time only a few steps away in the Berlin Palace, was completely ignored.

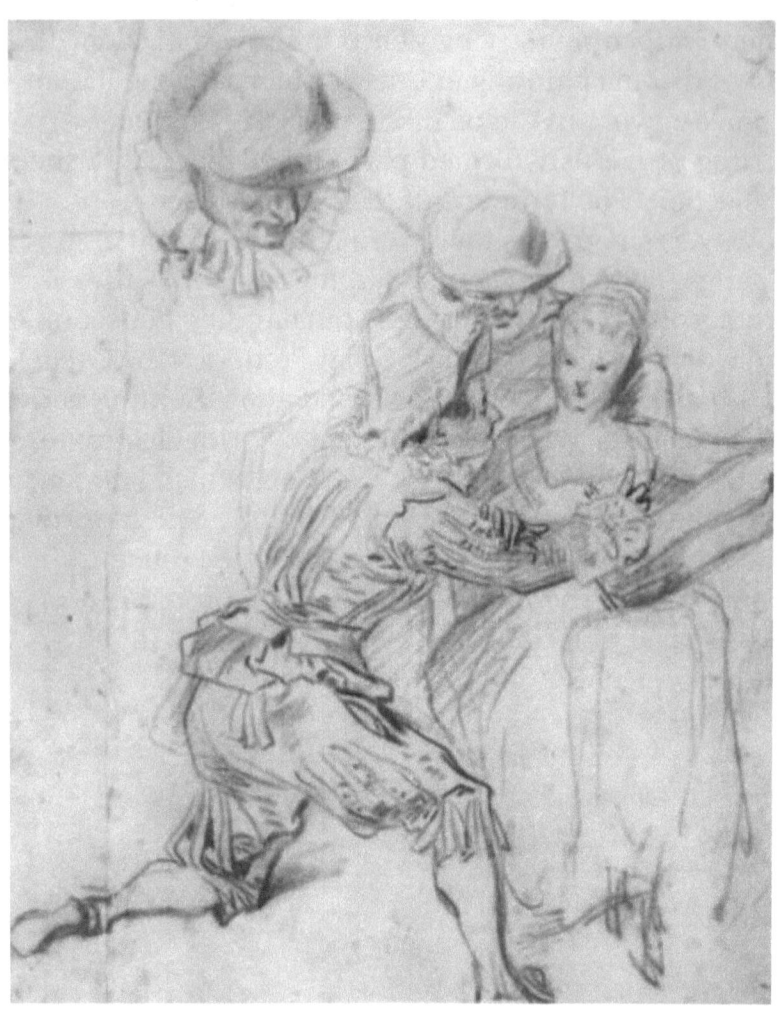

Study sheet, Seated guitar player, two comedians and study of a Pierrot
1716, sanguine and black chalk on paper, 35 × 27.2 cm

Antoine Watteau

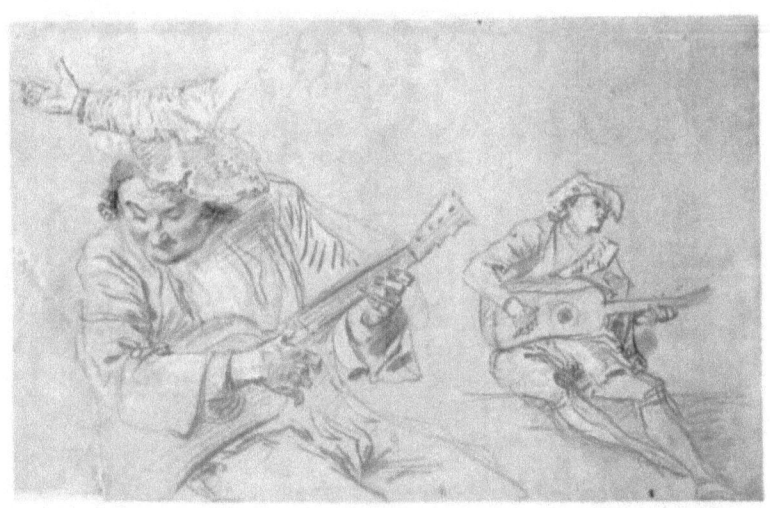

Study sheet, two guitar players and a sketch right arm
1716, Red, black and white chalk on gray-brown paper,
24,4 × 37,9 cm, The British Museum, London

Jessica Findley

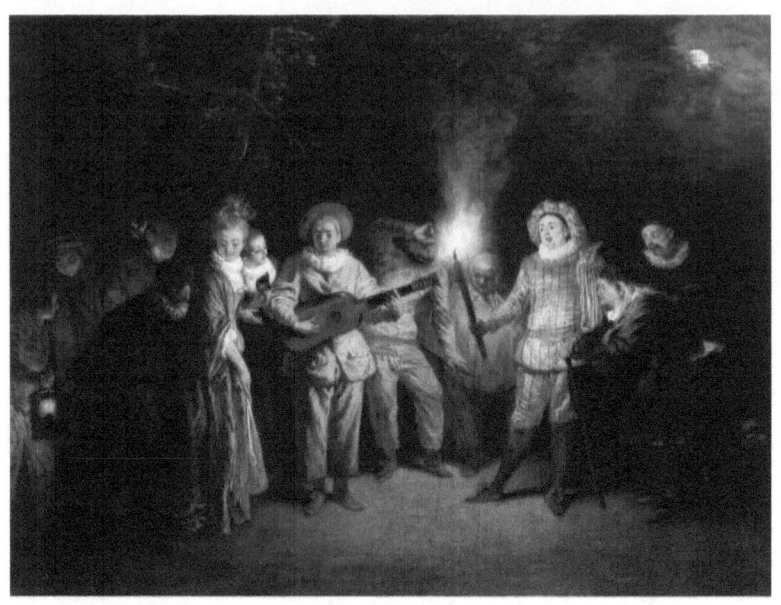

The Italian Comedy
c. 1716, Oil on canvas, 37 x 48 cm

Antoine Watteau

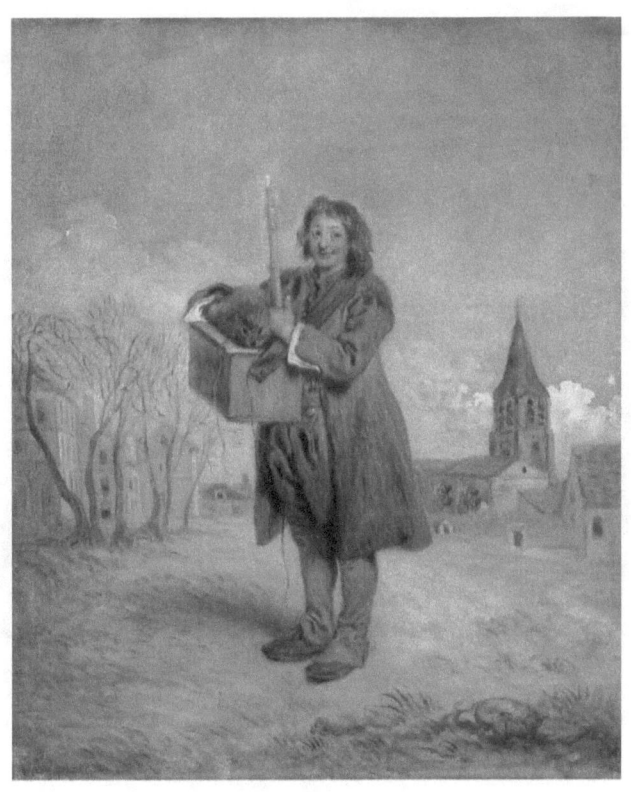

Savoyard with a Marmot
1716, Oil on canvas, 41 x 33 cm

Everything here is archaic: the peasant type posing awkwardly in the centre has its origins in 17th-century engravings; the landscape seems completely separate, like a theatrical backdrop. But in Watteau's hands these vestiges of the past became a retrospective view that is not only touching but also intelligent. Even the timidity evident in the molding of the figure works to the benefit of the stylisation.

Jessica Findley

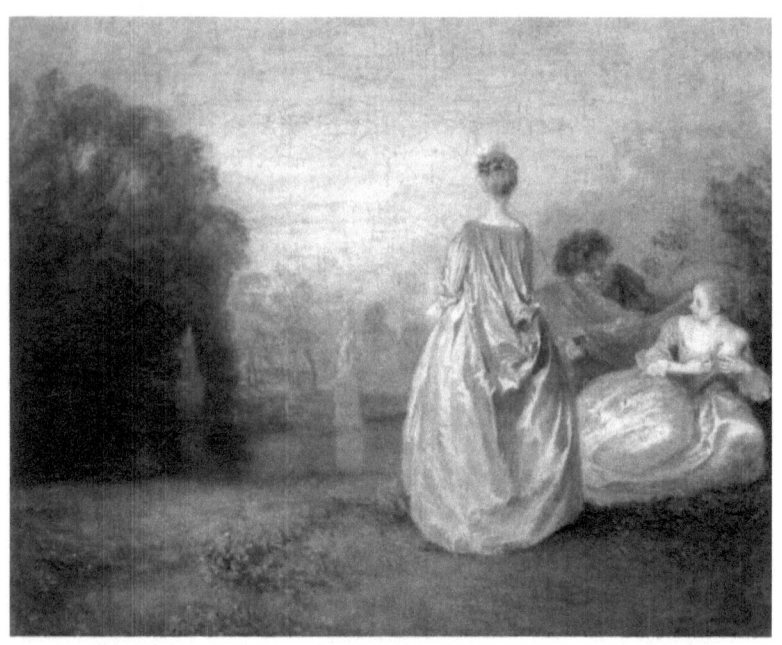

Two Cousines
c. 1716, Oil on canvas, 30 x 36 cm

Antoine Watteau

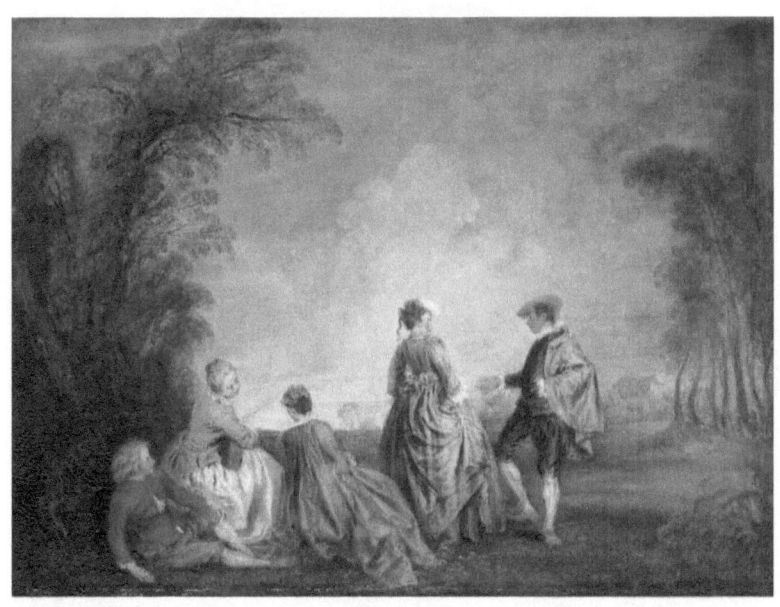

An Embarrassing Proposal
c. 1716, Oil on canvas, 65 x 85 cm

One of the gallant scenes in which Watteau precisely captured the 18th-century's theatricalized view of the world shows not a stage production but people dressed and behaving in a theatrical manner, perceiving the world and themselves as a performance. Most important here is the atmosphere, the figures dissolved in the landscape, the general haze of colours, in which the shades of sky, foliage, and expensive fabrics coexist on equal terms.

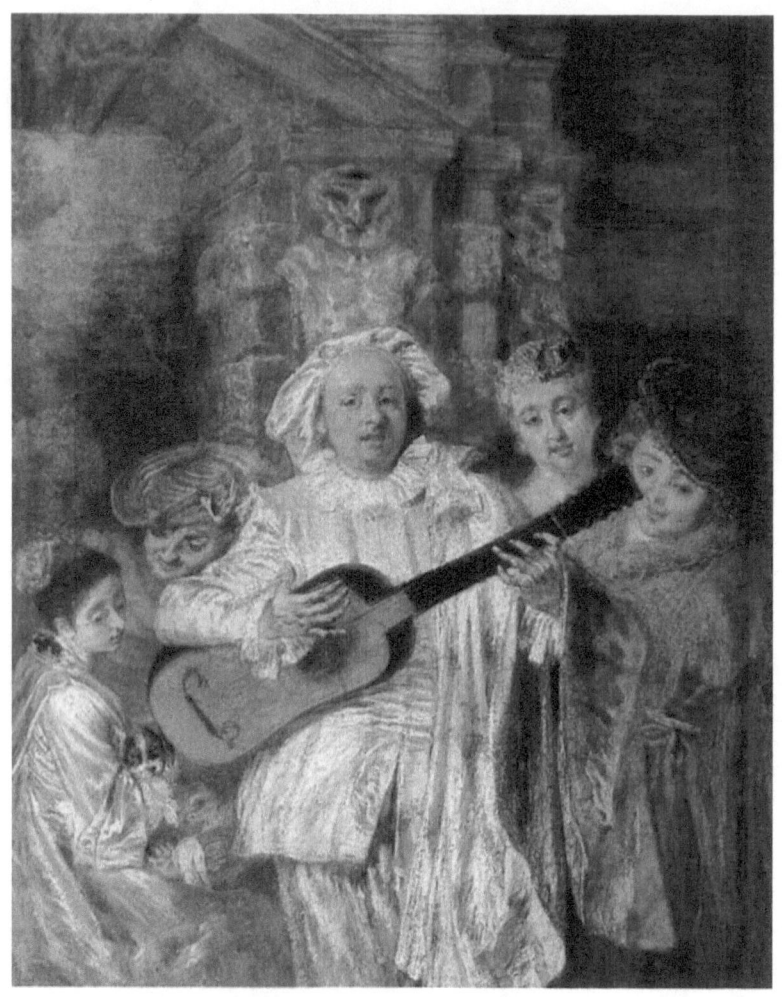

Gilles and his Family
c. 1716, Oil on wood, 28 x 21 cm
A drawing for the central figure of Mezzetin identifies the model as Watteau's friend and patron Pierre Sirois, but the composition is fanciful rather than a family portrait.

Antoine Watteau

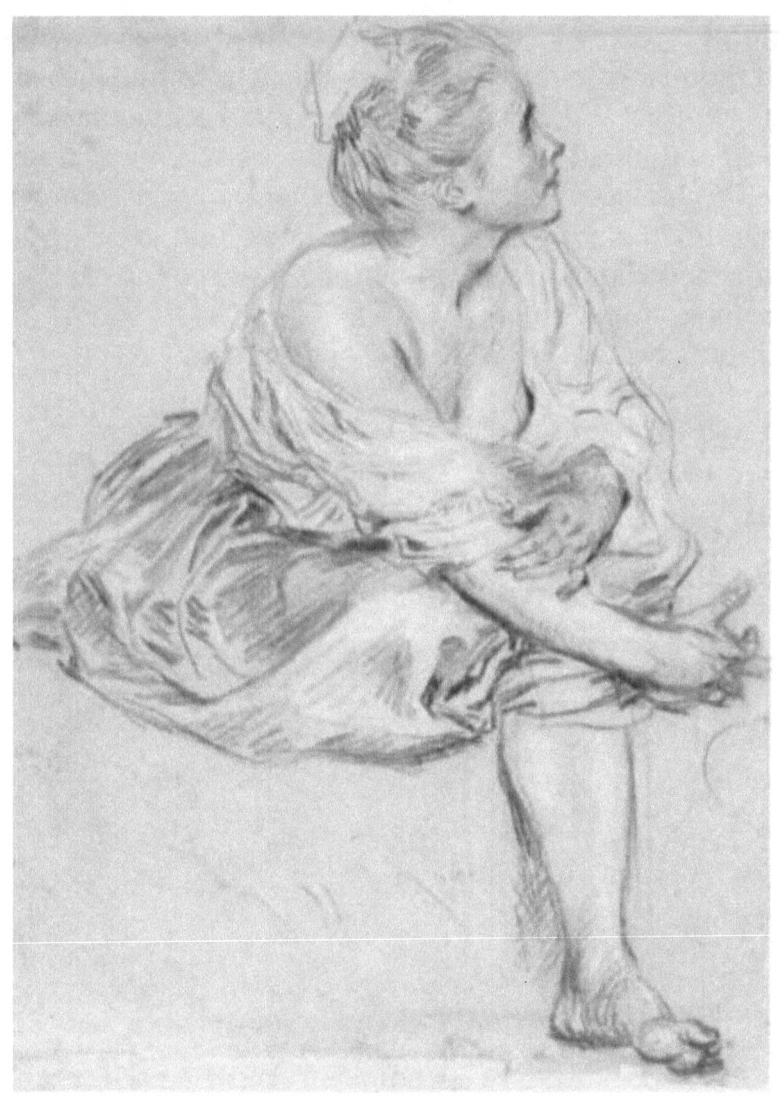

A Seated Woman
1716, The Morgan Library and Museum, New York

In this drawing Watteau studies with sensuous attention a woman's body, very much 'from the life', a few delicate touches of sanguine crayon conveying the flesh and blood of ear, hands, and foot, while strokes of white chalk suggest the sheen of the skin. In this superb drawing the body is fondly delineated as at once wrapped and yet revealed by the creased, almost rustling draperies, caught up to expose a calf and slipping down to give glimpses of a breast.

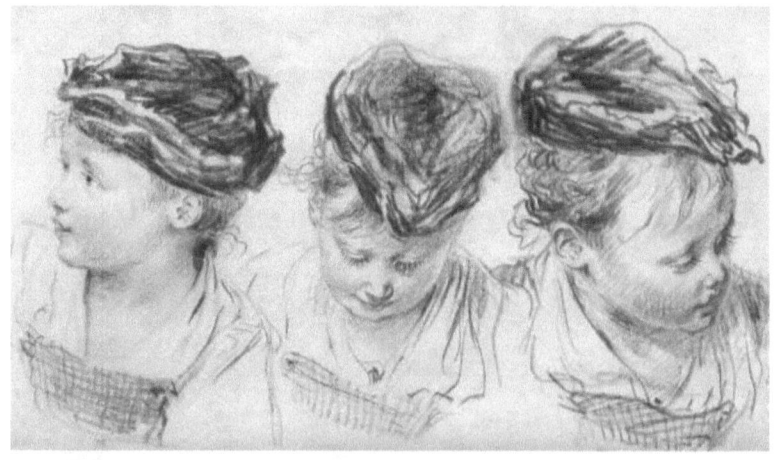

Three Studies of a Young Girl Wearing a Hat
1716, Red and black chalk and graphite on paper

Antoine Watteau

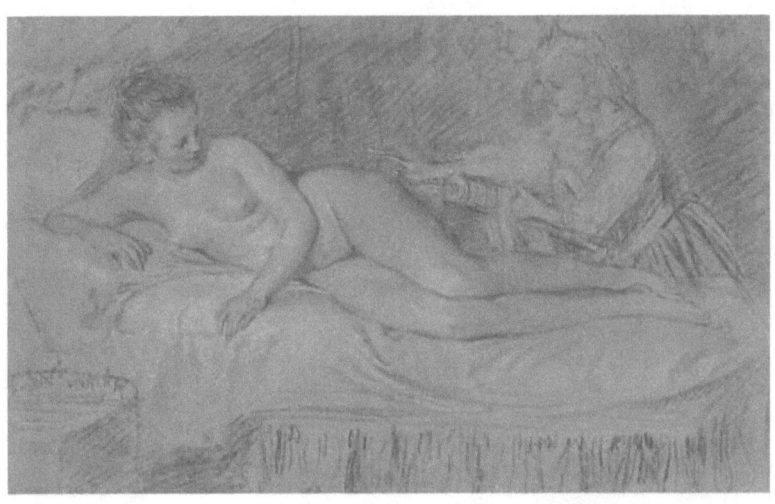

The Remedy
1716 - 1717, Red, black, and white chalk, 23,4 × 37 cm,
Paul Getty Museum

A young woman lies on her bed, provocatively displayed in the nude, while a nurse leans attentively over her, ready to administer an enema. Jean-Antoine Watteau drew the scene with perfect mastery, using a subtle patterning of red, black and white chalk lines to create shadows and highlights. In drawings such as this one, he made this technique, known as trois crayons, famous. He sketched the nurse's head twice, trying two different angles over another study of the model's head. Watteau made this highly finished drawing in preparation for a painting now in the Norton Simon Museum. The severely trimmed painting lacks the nurse and severs the nude below her knees.

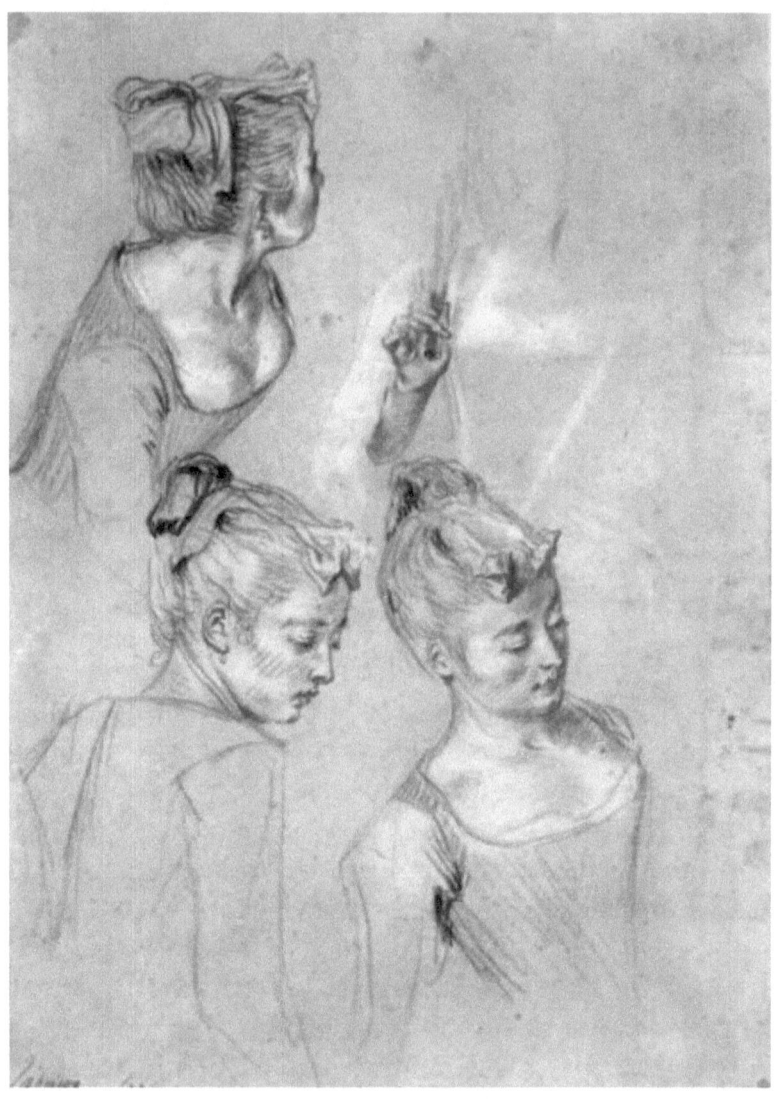

Three Studies for a girl
1716-1717, Red, black and white chalk on brownish paper, 34.3 × 23.1 cm, Musée du Louvre

Antoine Watteau

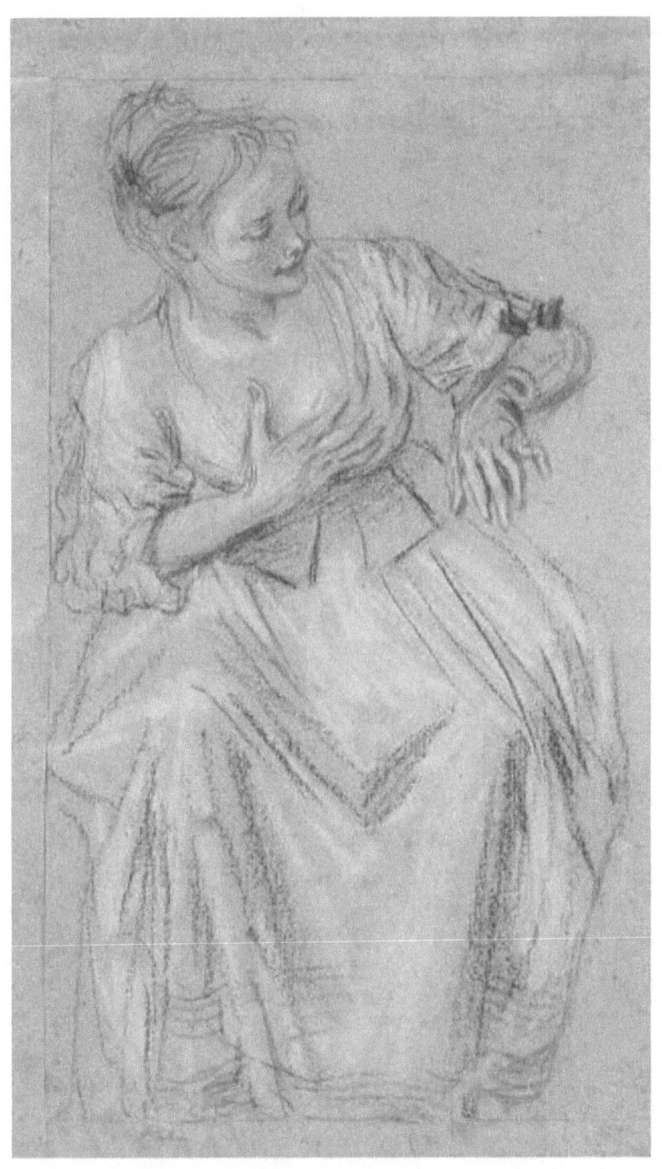

Seated Woman
1716–17, Black, red, and white chalk, 24 x 13.8 cm, The Metropolitan Museum of Art

Jessica Findley

In the rapid spontaneous execution of this sheet, Watteau's mastery of the trois crayons or "three-chalk" technique is fully evident. Freely mixing red, black, and white chalk, he captured the young woman's loosely pinned-up hair, luminous flesh tones, and the sheen of her dress. Her high cheekbones, broad forehead, and pointy chin all suggest a favored type — or model — appearing frequently in Watteau's oeuvre. The figure does not seem to have been used in a painted composition and the woman's gesture is not easily understood, although her elegance and charming lack of self-consciousness come through clearly.

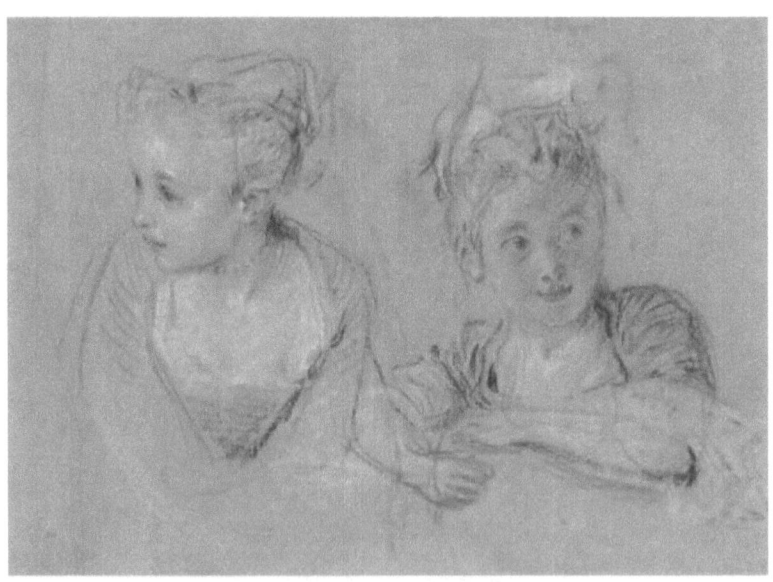

Two Studies of the Head and Shoulders of a Little Girl 1716-17; Red, black and white chalks on buff paper, 18.7 x 24.4 cm, Pierpont Morgan Library, New York

Antoine Watteau

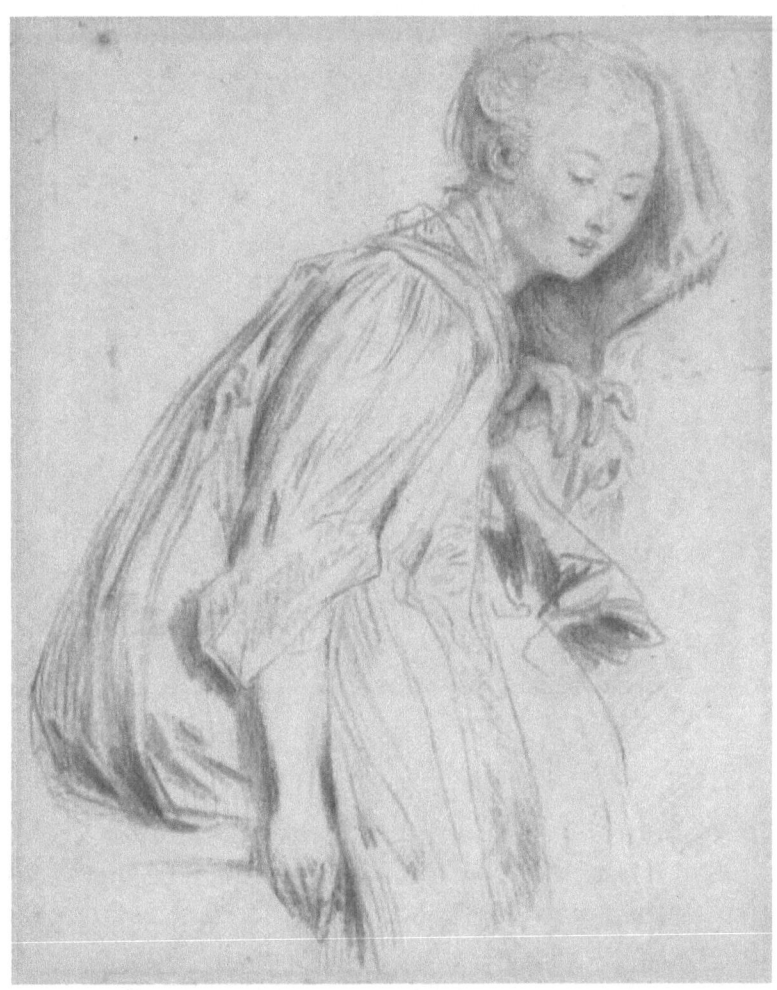

A seated young woman, in a loose robe, her eyes downcast
1716-17, reworked black and red chalk counterproof, 23.4 x 18.5 cm, Private Collection
This figure appears, in reverse, in the middle-ground of Watteau's La Game d'Amour in the National Gallery, London. The present drawing must date from about the same time that the painting was executed.

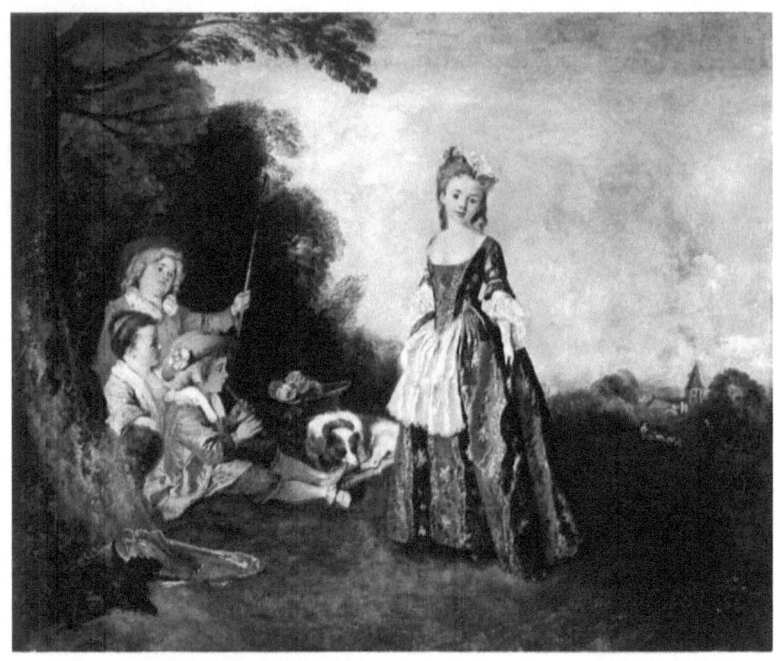

The Dance
1716-18, Oil on canvas, 97 x 116 cm
Three children have sat down in the open under a tree to make music. A small girl stands in front of them and seems to pause in the act of dancing. In the distance a village church can be seen. The age of the young dancer seems strangely indeterminate; not yet full grown, she nevertheless gives the impression of being remote from the world of children. As in almost all Watteau's pictures, there is a touch of sadness in this scene.

Antoine Watteau

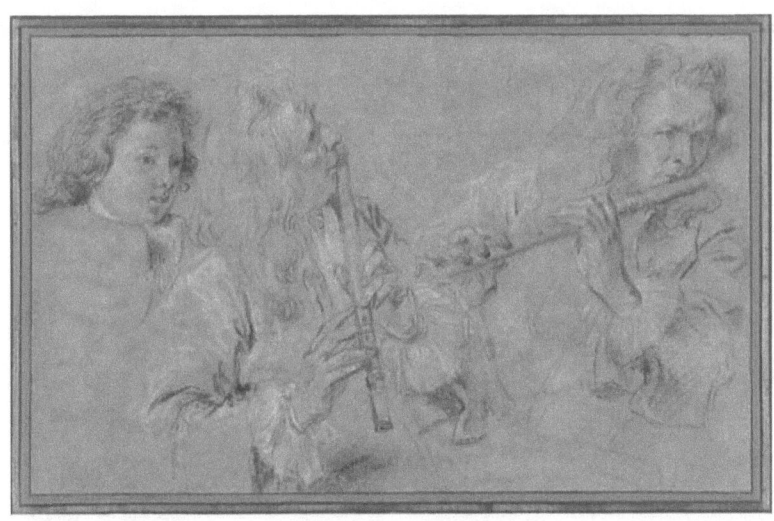

Two Studies of Flutist and Head of a Boy
1716 - 1719, Red, black, and white chalk on buff-colored paper, Paul Getty Museum

This sheet of three studies shows two views of a man playing a flute next to the head of a boy looking on. Jean-Antoine Watteau observed the flutist from life and captured his expression of keen concentration as he blows his breath through pursed lips and the elegant movement of his fingers on the keys of the instrument. Watteau was a master of the technique known in French as trois crayons, a combination of red, black, and white chalks, usually on tinted paper. Here he suggested texture by the play of light on drapery and other details such as the shape of the musician's long, tapered fingers, the sweep of his wavy hair, and the softness of the white lace around his wrists.

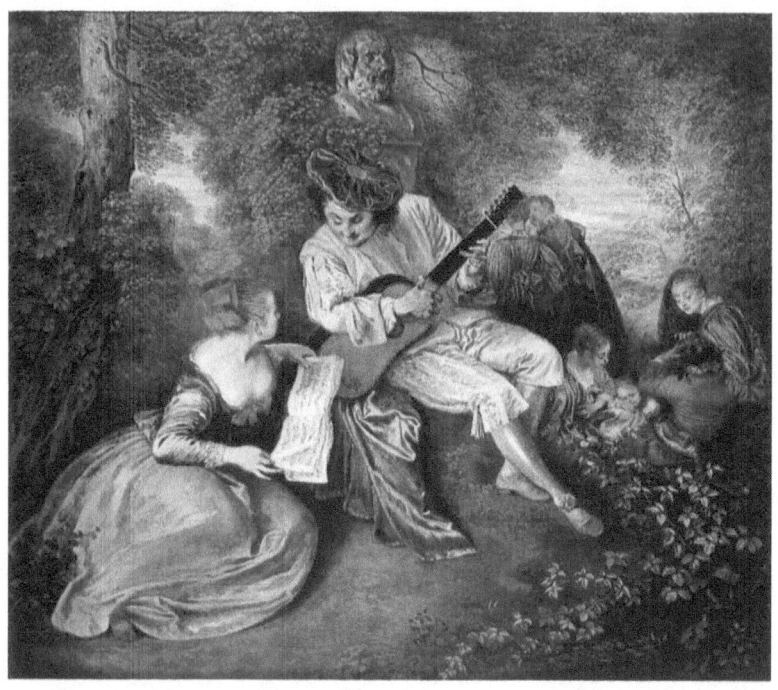

'La gamme d'amour' (The Love Song)
c. 1717, Oil on canvas, 51,3 x 59,4 cm

During the early eighteenth century the lute was replaced by guitar in the artistic depiction of musical groups and other amorous scenes. The fashionable instrument appears in a number of Watteau's canvases showing garden parties or intimate duets. The erotic connotation remained unchanged.

Watteau's contemporary Bernard Picard accompanied his engraving entitled Concert in the Park with a few playful couplets about the contest between Apollo and Amor, which can be summed up this way: "Both of them was victorious; Apollo at the beginning, Amor at the end." The contemporary public certainly noted the piquant allusions and understood the ironic innuendo.

Antoine Watteau

The painting depicts the moment when the two musicians "tune on" before a performance. The singer gives the initial tone, and the accompanist finds the matching chord. This playful context is well matched by the virtuoso placing of the two figures within the diagonal composition, by the gentle harmony of pastel colours and by the formal lightness of the composition.

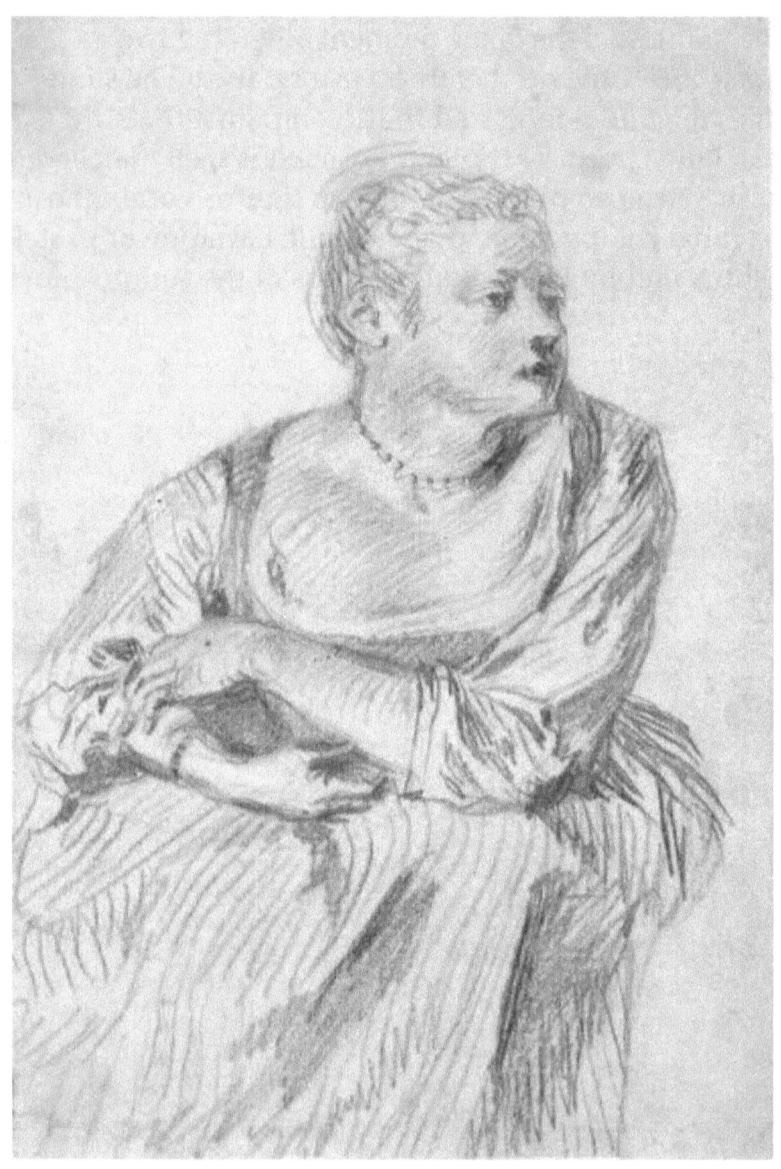

Study of a seated woman
1717, Red and black chalk, Private Collection

Antoine Watteau

The outstanding French drawing is an exquisite study of a seated woman by Jean-Antoine Watteau made in preparation for the artist's 1717-19 painting known as Les Bergers, now in the collection at Schloss Charlottenburg, Berlin. The drawing is executed in a combination of media that Watteau used only occasionally, but to striking effect: the majority of the figure is built up with a network of silvery strokes of graphite, while the accents in the face and hands are in a more typical red chalk, an extremely effective juxtaposition that creates a lively yet utterly elegant figure.

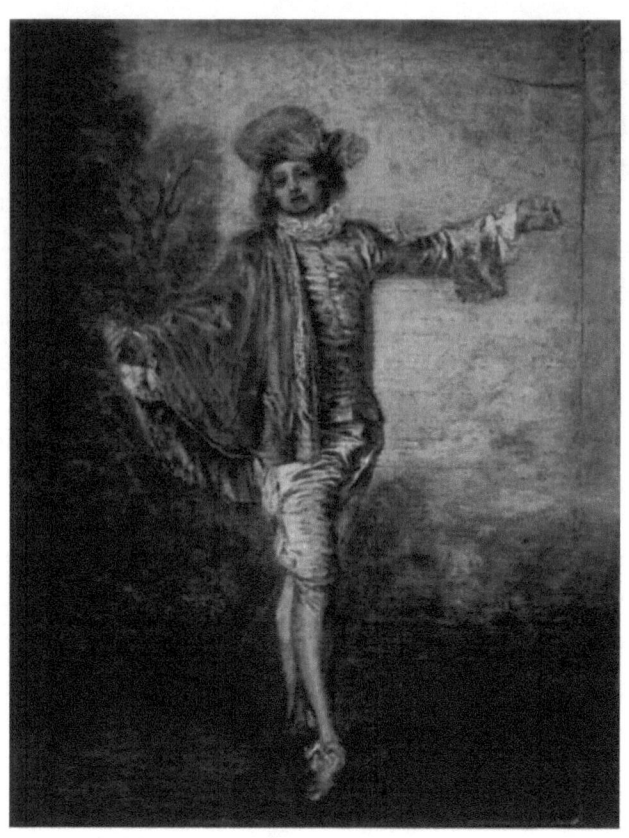

L'Indifferent
c. 1717, Oil on panel, 25 x 19 cm

The painting is also known as The Casual Lover. Shining folds of silk give the figure of carefree young man a delightful shimmer appropriate to his pose. He is about to execute a dance step. Watteau was always drawn to the inaugural moment of an action. The surface of this small panel suffered from clumsy restoration.

Antoine Watteau

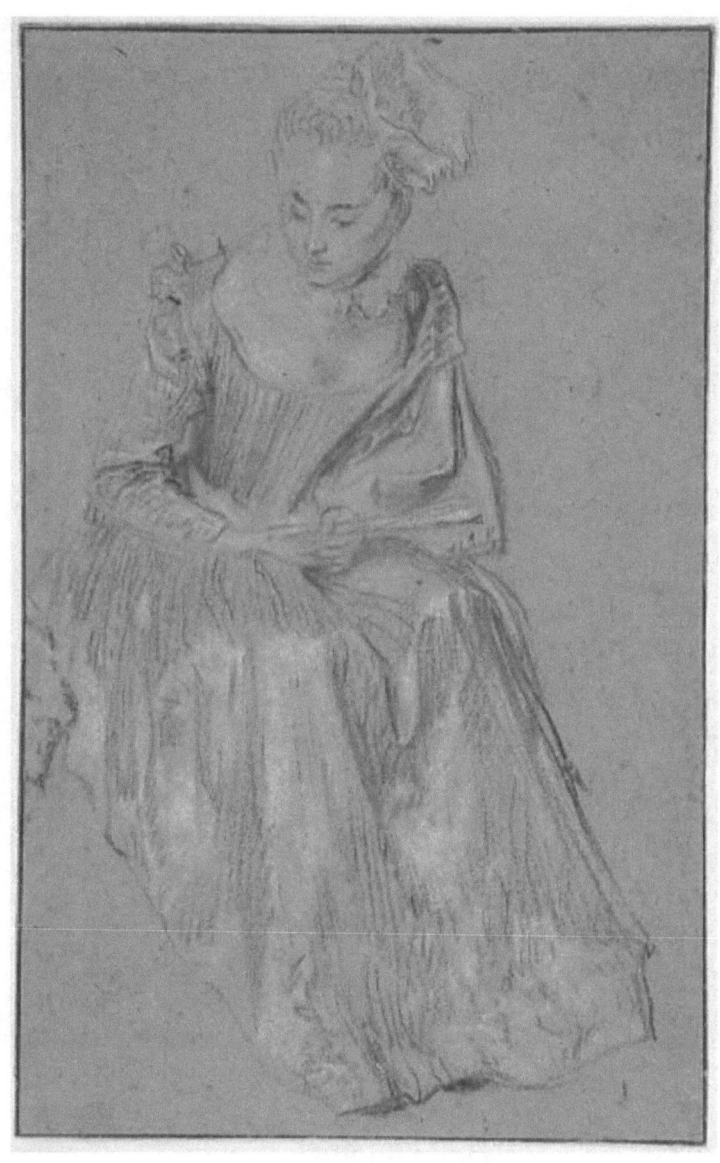

Seated Woman Holding a Fan
1717, Red, black, and white chalk, 21.3 x 20.6 cm, The Metropolitan Museum of Art

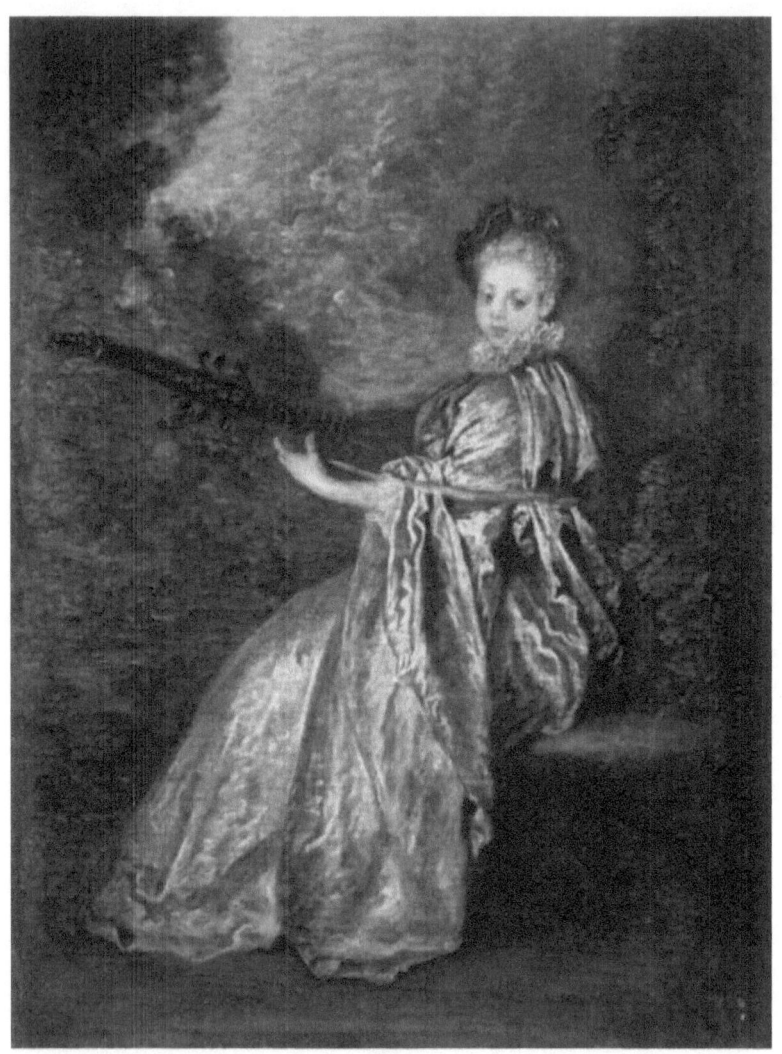

La Finette
c. 1717, Oil on panel, 25 x 19 cm
The painting is also known as The Delicate Musician.

Antoine Watteau

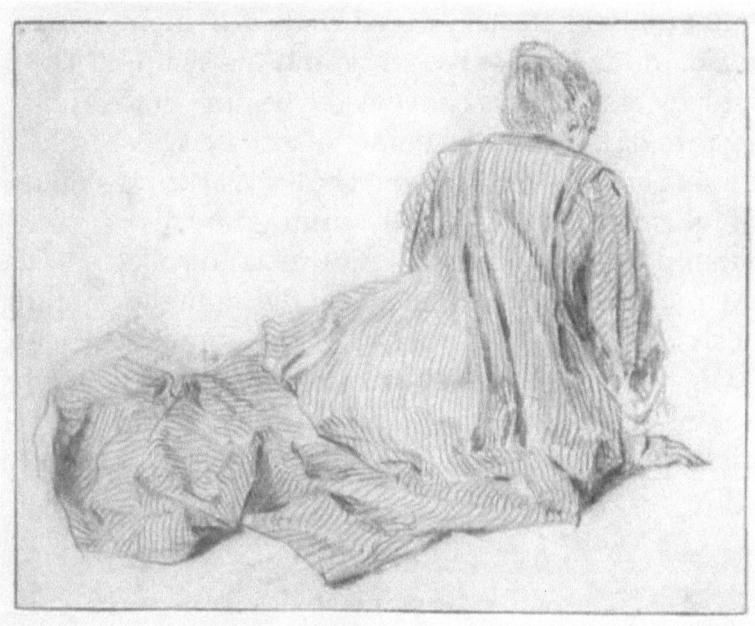

Woman in a striped Dress, a drawing
1716-18, The British Museum, London

This drawing is done in red and black chalks with pencil. Although not highly finished, it is a superb study of the costume of the woman as she sits and leans forward, her weight carried on both her hands. Her legs are hidden beneath her long dress, though we can see their position by the arrangerment of the drapery. The woman's contour is outlined in pencil. Red chalk lines, in long stripes, indicate the pattern of the dress as it falls over her body. Drapery shadows are shown by the rubbed deep red chalk, especially on the back of her right sleeve and over her feet. Watteau altered the position of the fabric over her feet by lowering it for the final position.

Watteau's total mastery of red chalk is evident in his control of the lines of the fabric and the shading. The dress, by association, conveys the beauty, grace and elegance of the young woman, whose body is barely visible. Overall, this drawing shows Watteau's skill as a draughtsman; he was greatly admired by his contemporaries, including followers and collectors. The drawing was used for the central figure in the painting, Plaisirs d'Amour ('Pleasures of Love') now in Dresden, and again in the Divertissements champêtres ('Country amusements'). It was also much admired by the French artist, François Boucher, who engraved it.

Antoine Watteau

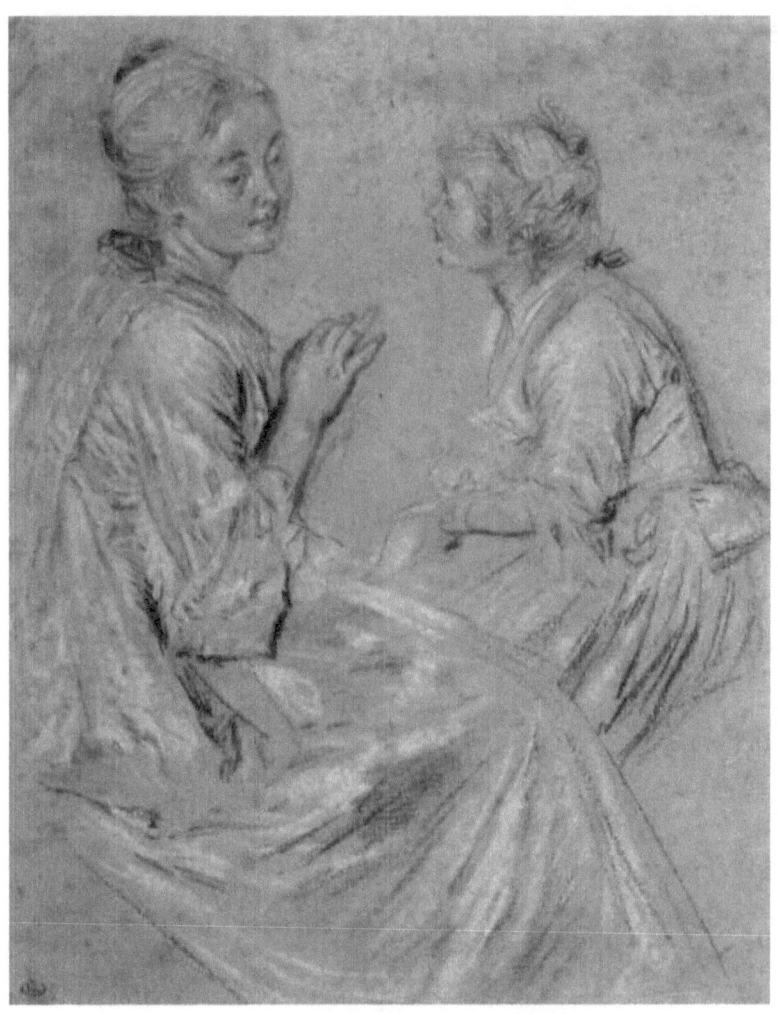

Two Seated Women
1716-17, Black, white and red chalk, 212 x 352 mm,
Musee du Louvre, Paris

A striking talent for drawing enabled Watteau to produce numerous sketches full of life and feeling, using the "trois crayons" technique (red, black, and white chalk). Like Rubens, he was able to capture the vitality of female models.

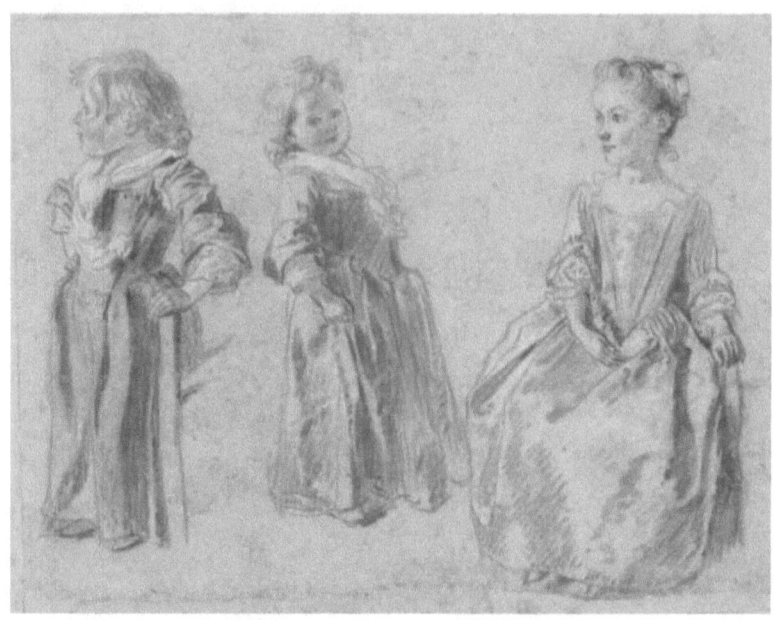

Two studies of a young child standing, and another of a young girl seated
1716-1717, Red, black and white chalk, 24.8 x 32 cm, Private Collection

This sheet of two studies of a child standing, and another of a seated girl, is utterly characteristic of the artist in several respects -- in its handling of trois crayons, in its arrangement of figures on the page, and in their adaptation and inclusion in multiple painted compositions.

Antoine Watteau

Among 18th Century artists, Watteau is the unsurpassed master of the trois crayons drawing. This technique derived from Rubens in the 17th Century but was transformed by later French artists such as Charles de la Fosse and ultimately reached its zenith with Watteau. In the present sheet, red chalk predominates while black is used in the hair of all three figures, but as accents only on the figures at the right and left. The white chalk is used for all three figures to highlight both their faces and clothing. In his handling of the red chalk alone, the diversity of technique is extraordinary. Short, jagged strokes and softer passages of hatching are combined to evoke the crisp folds of fabric. In contrast, an undulating line around the neck of the seated girl enhanced by a bit of white perfectly suggests the translucency and delicacy of her ruffled collar.

It is difficult, and indeed was unimportant to Watteau for the purpose of the drawing, to tell whether the two children at the left are boys or girls. Again, this is typical of Watteau's approach to these figures where the precise identity or use of them was less important than the pose he was trying to capture at that moment.

Jessica Findley

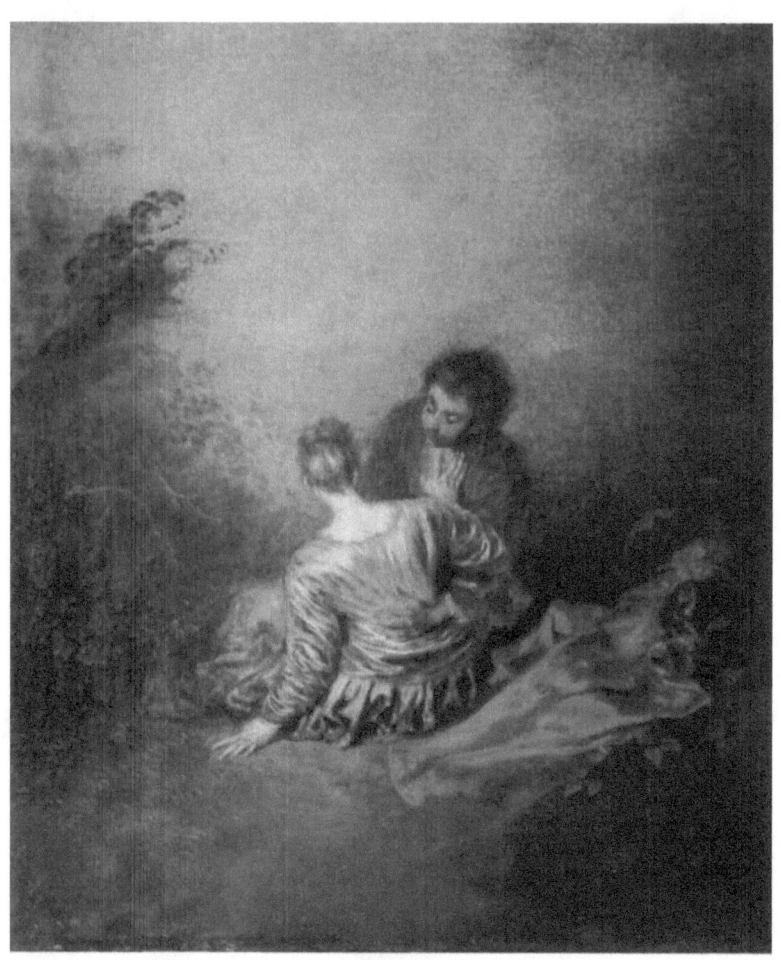

The Blunder
1716-18, Oil on canvas, 40 x 31 cm

Antoine Watteau

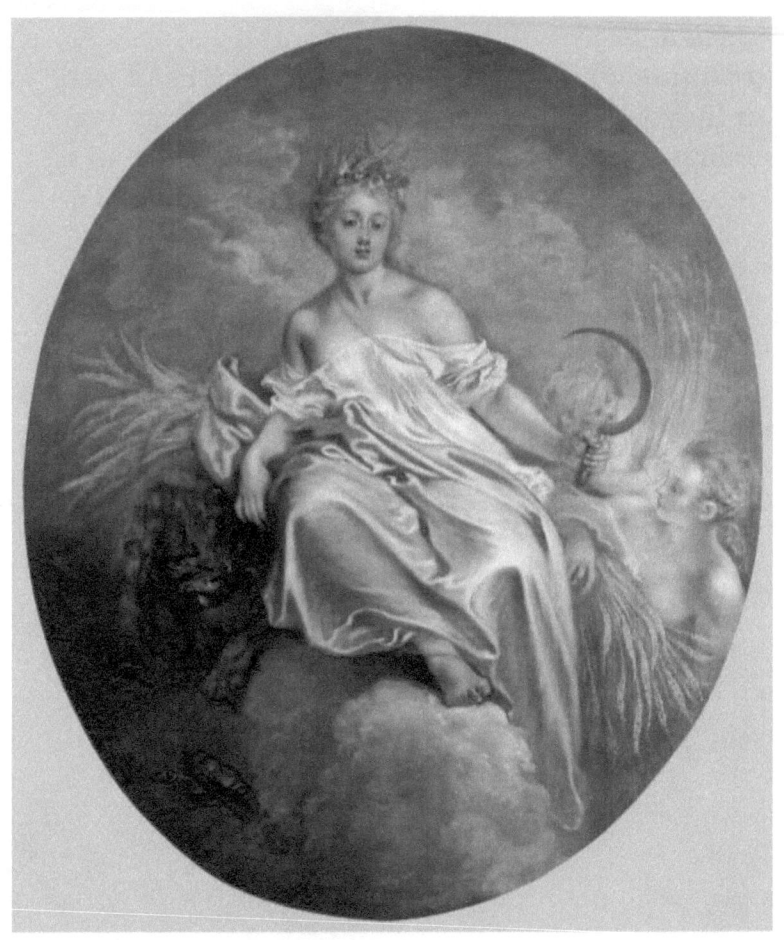

Ceres (Summer)
1717-18, Oil on canvas, 142 × 116 cm

In ancient Roman religion, Ceres was a goddess of agriculture who presides over Summer. The present painting originally formed part of a set of four oval paintings representing the Four Seasons. They most likely served as overdoors for the dining room of a Paris hotel where Watteau was living from about 1715-17. The other parts of the series were either lost or destroyed, but they were engraved for the compendium of prints after Watteau, the Spring by Louis Desplaces; the Summer by Marie-Jeanne Renard Dubos; the Autumn by Etienne Fessard; and the Winter by Jean Audran.

Antoine Watteau

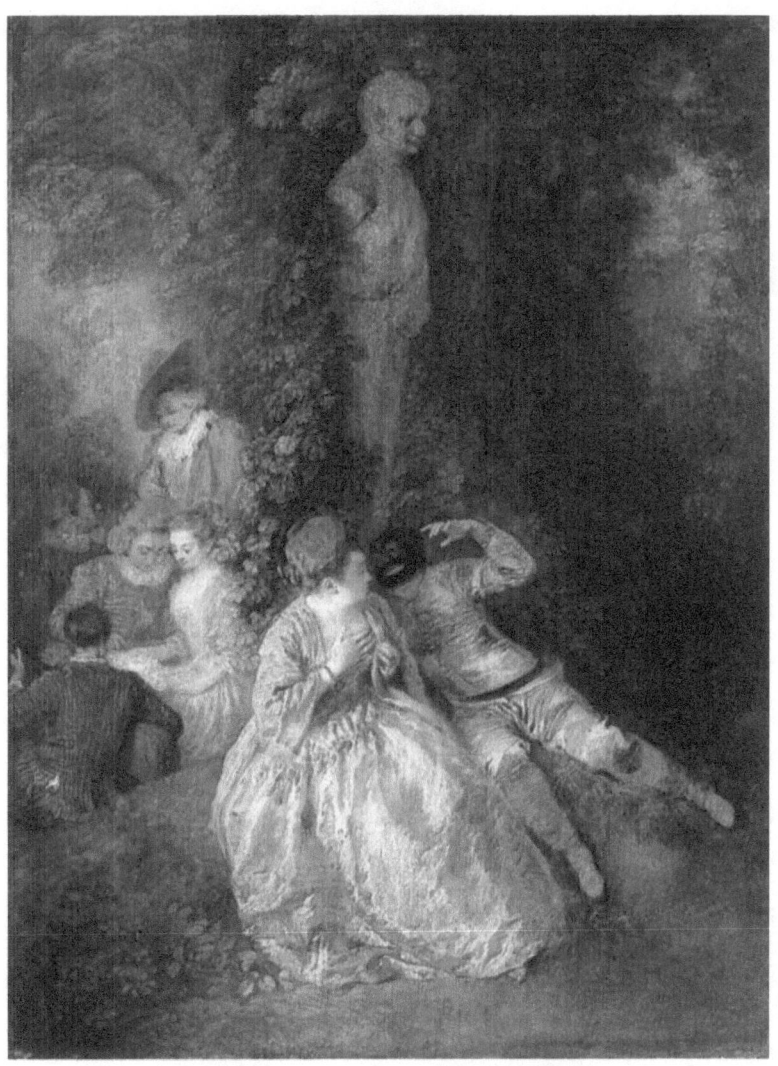

Harlequin and Columbine
1716-18, Oil on wood, 36 x 26 cm
The subject is a stock episode from the commedia dell'arte where the lively Harlequin makes proposals to Columbine.

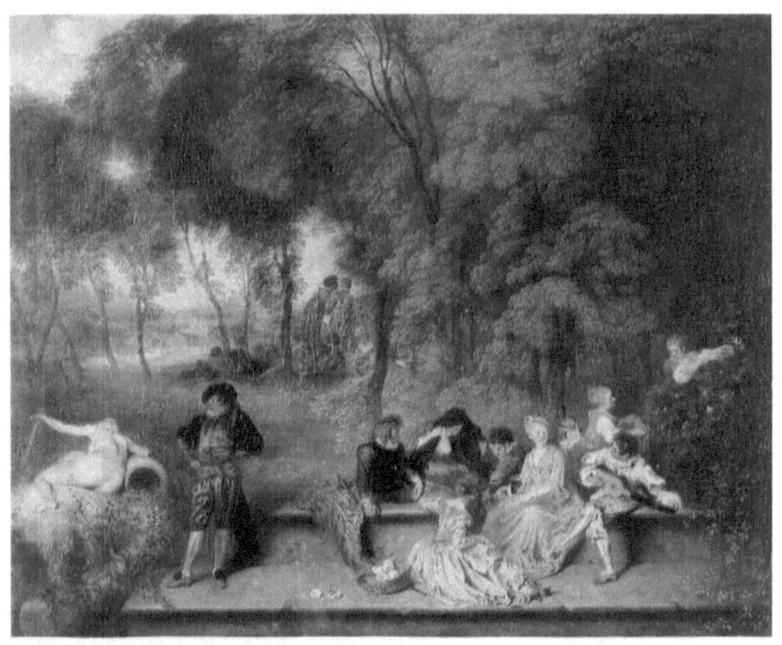

Merry Company in the Open Air
1716-19, Oil on canvas, 60 x 75 cm

Antoine Watteau

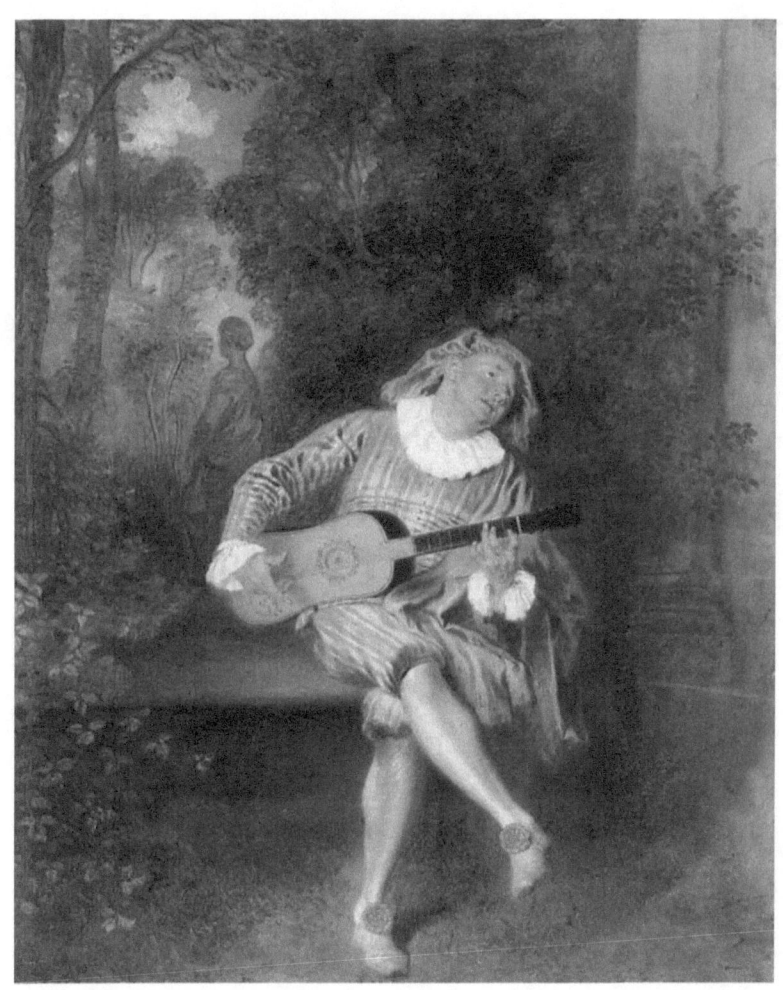

Mezzetin
1717-19, Oil on canvas, 55,2 x 43,2 cm

Mezzetin, a stock character of the commedia dell'arte, the improvisational theater form of Italian origin, was an amorous valet who frequently engaged in the pursuit of unrequited love. Here he is shown playing the guitar before a garden in which a young woman - perhaps a statue, perhaps the painting of a statue on a stage set - stands with her back turned, presumably rejecting his romantic entreaties. Such complex layering of multiple realities was one of Watteau's preoccupations. He delighted in the depiction of scenes imbued with the ambiguous relationship that existed between stage life and real life - the world of art and the actual world.

Antoine Watteau

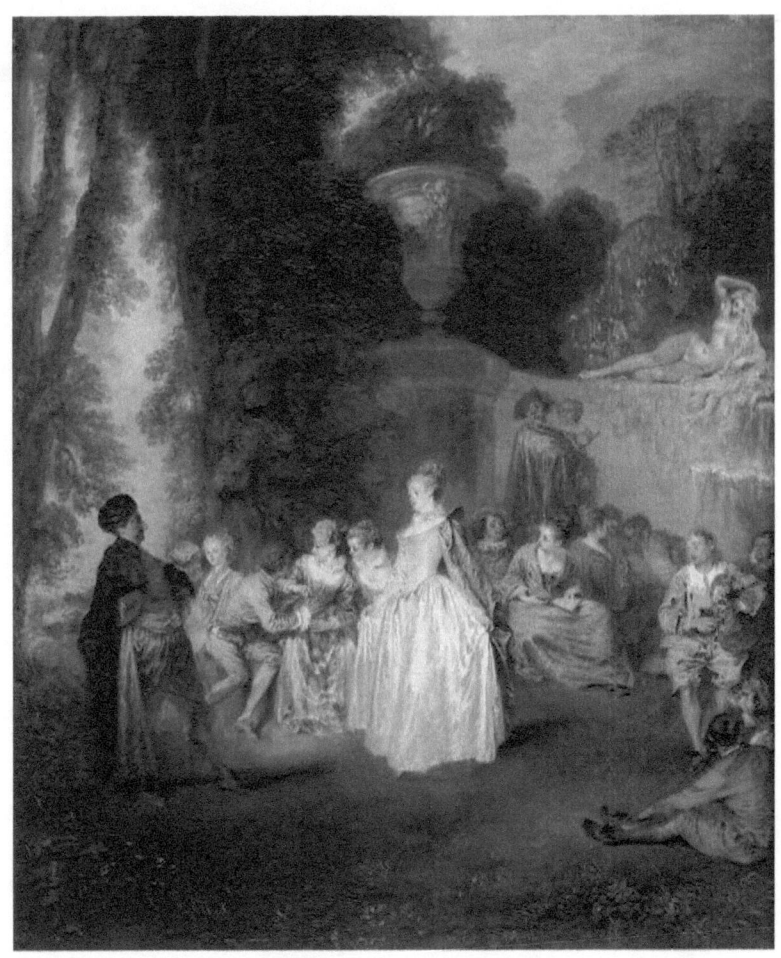

Fêtes Venitiennes
1718-19, Oil on canvas, 56 x 46 cm

Antoine Watteau brought the fête galante to its highest point when he created a mysterious, melancholy, dreamlike world populated by well-dressed people who flirt and play gracefully in parklike surroundings. The pastoral setting emphasizes the essential innocence and spontaneity of the participants, who are unafflicted by the stiffness imposed by the conventions of formal society. Eroticism is subtly rather than openly expressed. Fête galantes continued to be depicted by Watteau's pupils Nicolas Lancret and Jean-Baptiste Pater. The fête champêtre and fête galante ended with the termination of the Rococo period in the late 18th century.

Antoine Watteau

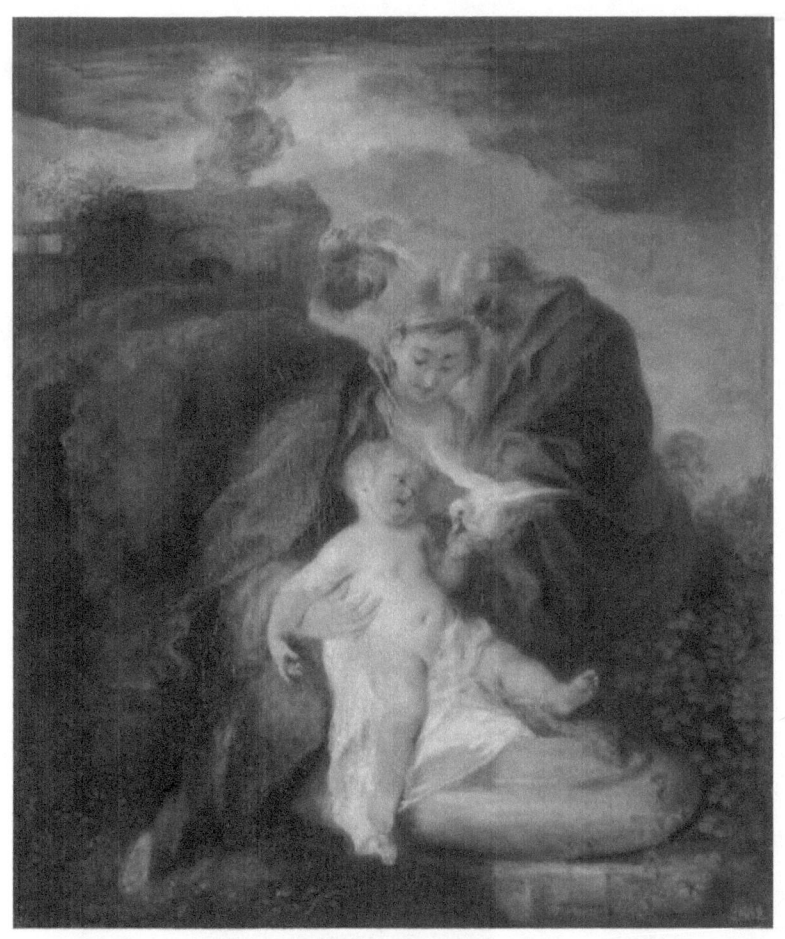

The Holy Family
1717-19, Oil on canvas, 117 x 98 cm

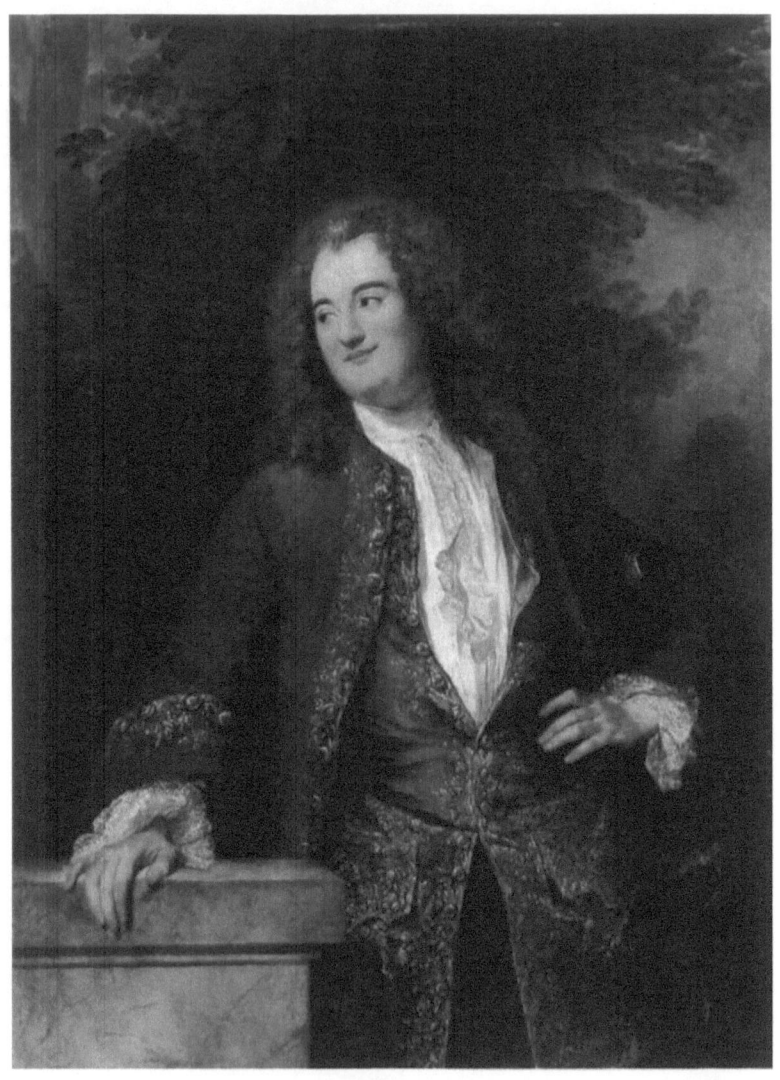

Portrait of a Gentleman
1715-20, Oil on canvas, 130 x 97 cm

Antoine Watteau

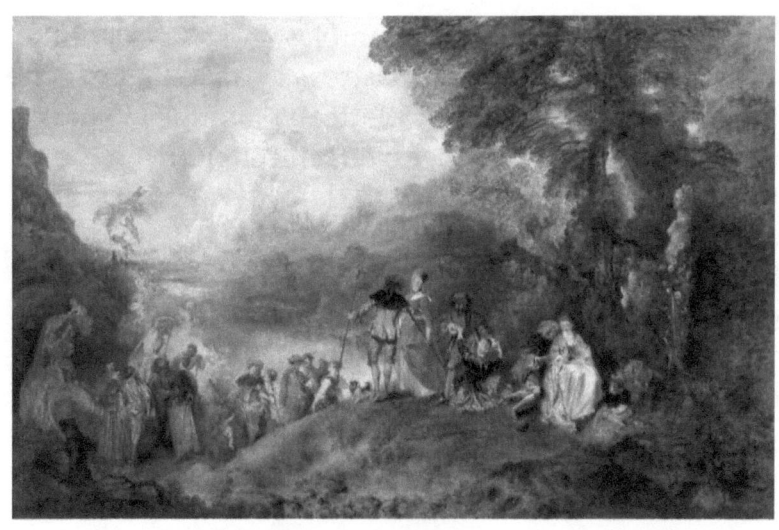

The Embarkation for Cythera
1717, Oil on canvas, 129 x 194 cm

This picture was Watteau's diploma piece for the Acadйmie royal de Peinture et de Sculpture. Watteau's nomination was accepted by the Acadйmie in 1712, but he had to be called to order several times and in 1717 he was given six months to execute his reception piece. He was received on presentation of his picture.

Love is a traditional theme of French poetry since the Middle Ages. From the beginning of the 18th century, the idea of departure for Cythera recurs in numerous ballets and operas.

The handle of the paint in scumbles and glazes, thinly applied, with very little impasto, is close to that of Rubens in his final period. Watteau was able to study his style of painting in the royal collection. Even the subject is derived from Rubens' Jardin d'Amour. Moreover, Watteau made a very close study of the Rubens painting in the Galerie Mŭdicis. There are also reminiscences of Italy in this enchanted land; the general atmosphere of the painting is Venetian, and the distant mountains in their blue haze recall Leonardo.

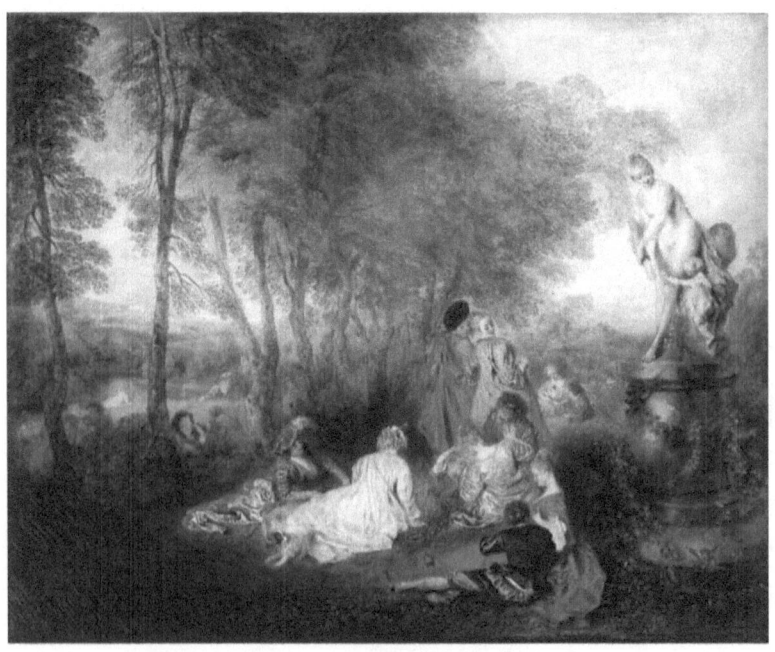

The Festival of Love
c. 1717, Oil on canvas, 61 x 75 cm

Antoine Watteau

Set in a curiously weightless landscape, an irregular row of trees enters the picture at an angle, affording us glimpses of meadows, stretches of water and buildings, with beyond a distant hill and a plane that vanishes into the depths. We see a number of couples, some reclining, some out walking, and a child and a small dog, both at the centre of the picture if not immediately visible. Opposite the soft, hazy trees that dominate the left half of the picture, the right-hand side is commanded by a statue of Venus, who has confiscated a quiver full of arrows from her son, Cupid.

A happy moment has been caught here by the painter's art, like a snapshot that captures a fleeting moment from the past — a gaze over a shoulder, a spontaneous gesture — and lends it permanence. Yet it would be absurd to assume that this scene was based on a real occurrence: the picture is a poetic invention by a painter, is itself the experience, and not a depiction.

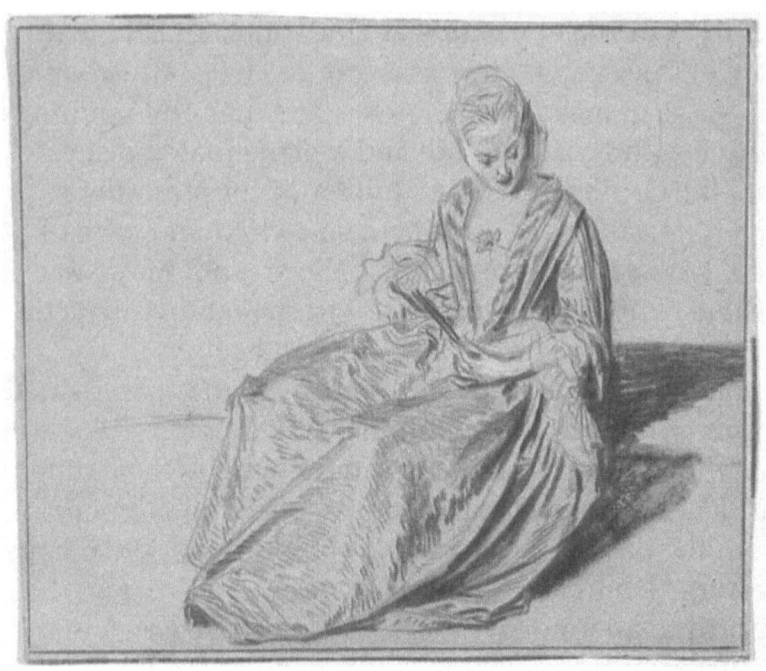

Seated Woman with a Fan
1717, Red, black, and white chalk on light brown paper,
Paul Getty Museum

Using a delicate pattern of red chalk lines to illustrate the play of light on the folds of the woman's silk dress, Jean-Antoine Watteau portrayed an elegant young woman in an unself-conscious pose. Black chalk strokes accentuate elements of emphasis: the closed fan in her hands, the outline of the edges of her dress, and the deep shadow behind her. White lines add areas of highlights. Watteau particularly favored the effects of combining three colors of chalk, red, black and white, a technique known as trois crayons .

Antoine Watteau

Watteau probably sketched the figure as a life study, not in preparation for a particular painting. Later, when he required a particular gesture or movement for one of his paintings, he would have referred back to this drawing. The breathtaking simplicity and elegance of this sketch display his virtuosity and inventiveness; others said that even Watteau preferred his drawings to his paintings.

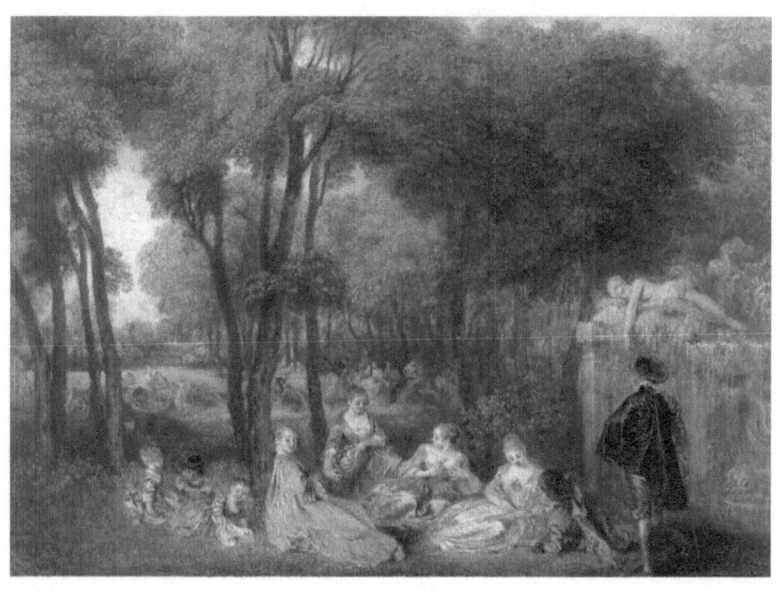

Les Champs Elysees
1717-18, Oil on wood, 31 x 42 cm

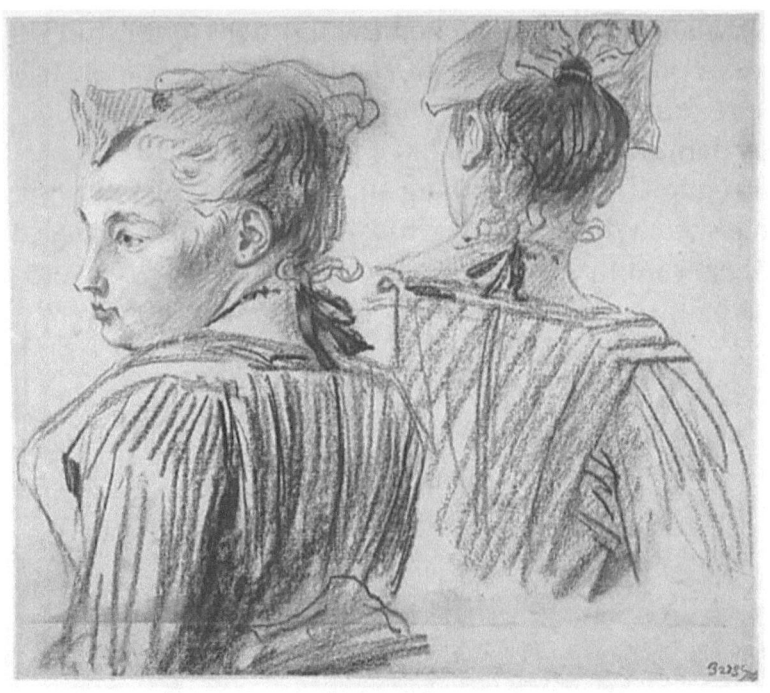

Studies of a Woman Wearing a Cap
1717–18, Black and red chalk, heightened with a little white, 18.4 x 20.5 cm, The Metropolitan Museum of Art

Antoine Watteau

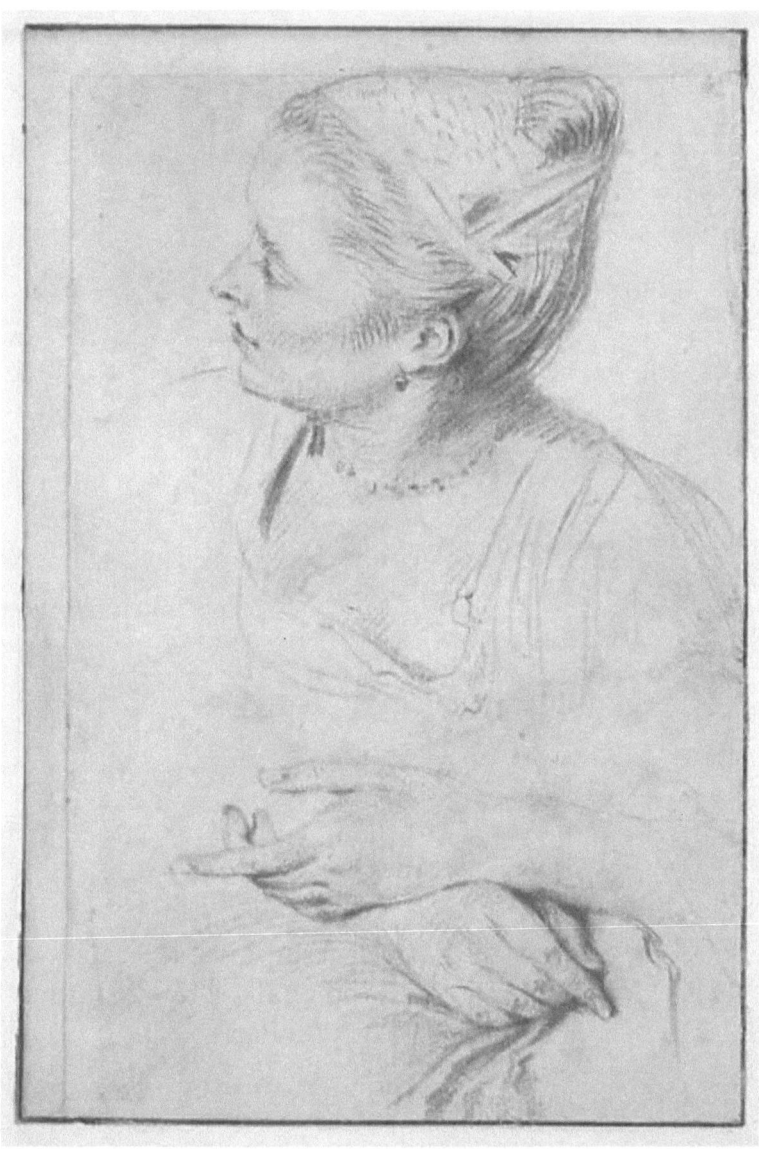

Study of a Woman's Head and Hands
1717, Red and white chalk and graphite on off-white laid paper, 19 x 12.7 cm, The Metropolitan Museum of Art

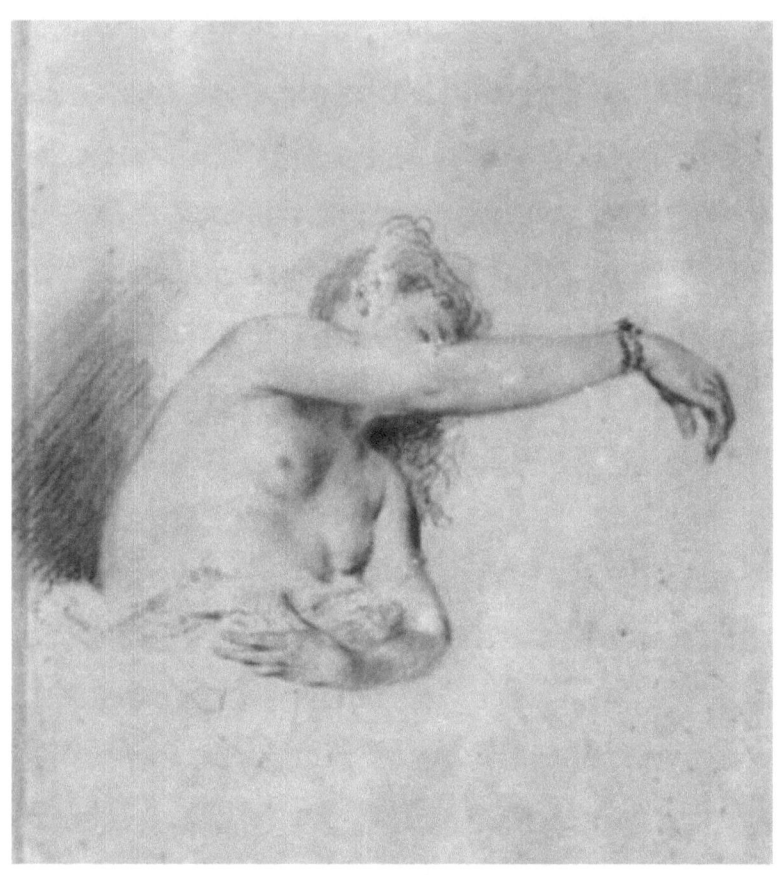

Nude with Right Arm Raised
1717-18, Black, white and red chalk, 282 x 233 mm,
Musee du Louvre, Paris

Antoine Watteau

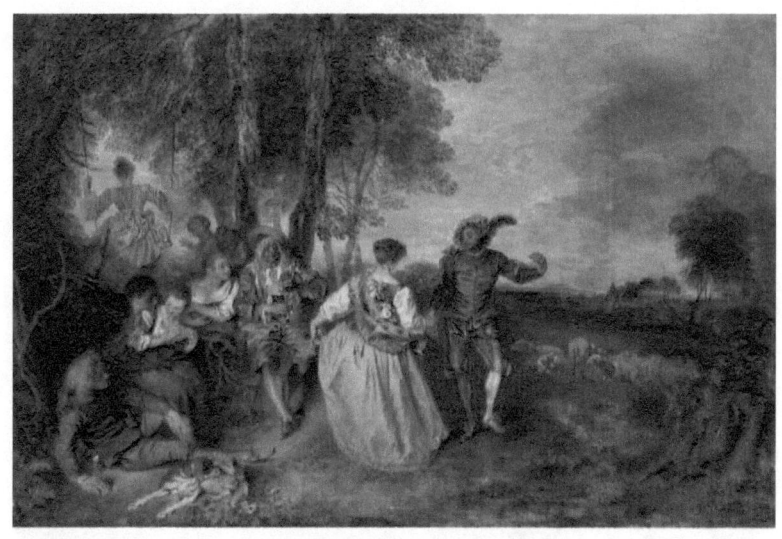

The Shepherds
1717-19, Oil on canvas, 56 x 81 cm

The painting shows rich people playing at peasantry, a practice that had been popular in France since at least the days of the early fifteenth-century Burgundian ducal court at Germolles. Watteau's amorous ladies and gentlemen assume the purportedly readier eroticism of rustic life as they dance, push, or grab one another while a bagpiper provides the "food of love."

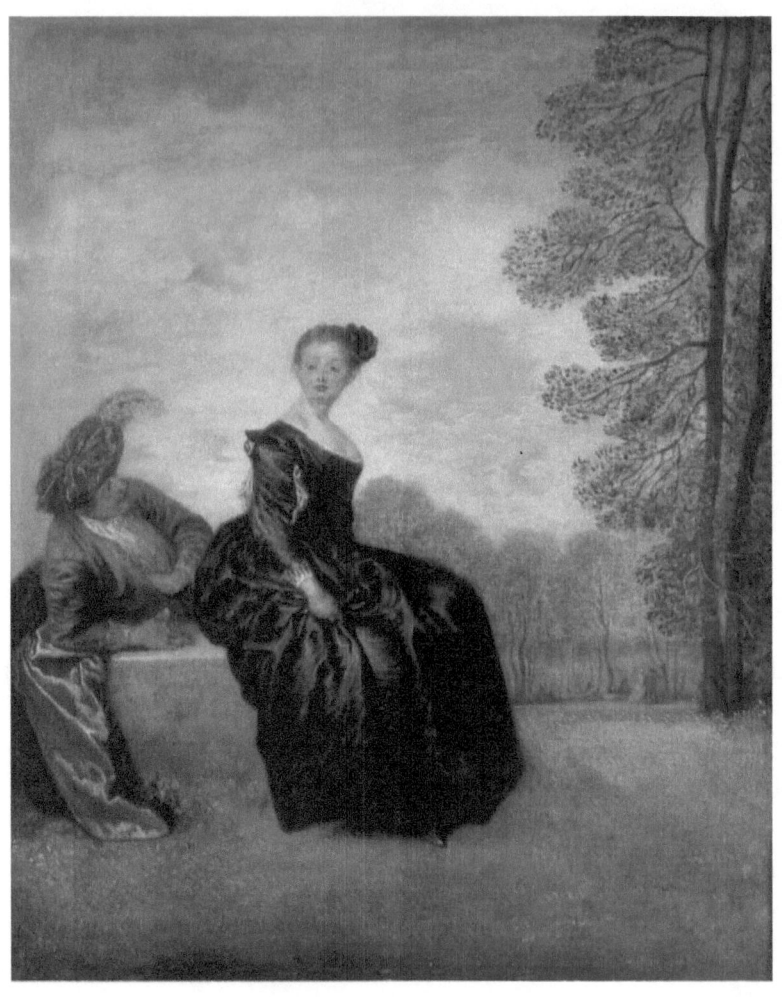

La Boudeuse (A Capricious Woman)
c. 1718, Oil on canvas, 42 x 34 cm

Antoine Watteau

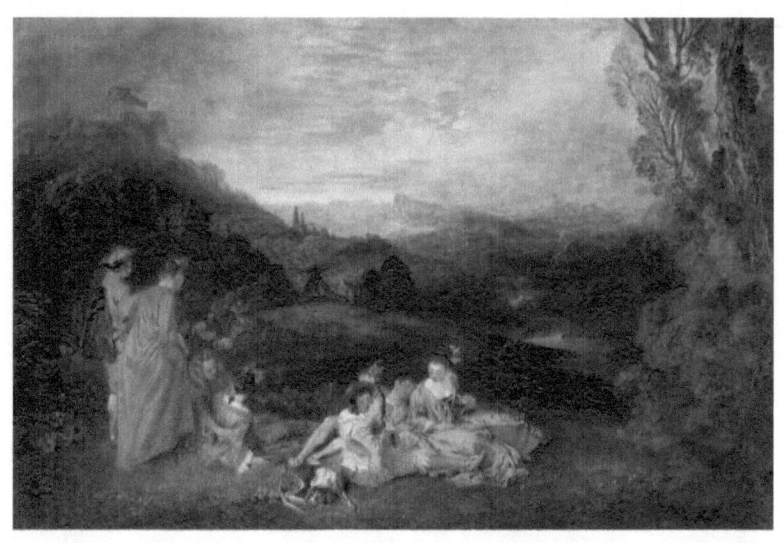

Peaceful Love
c. 1718, Oil on canvas, 56 x 81 cm

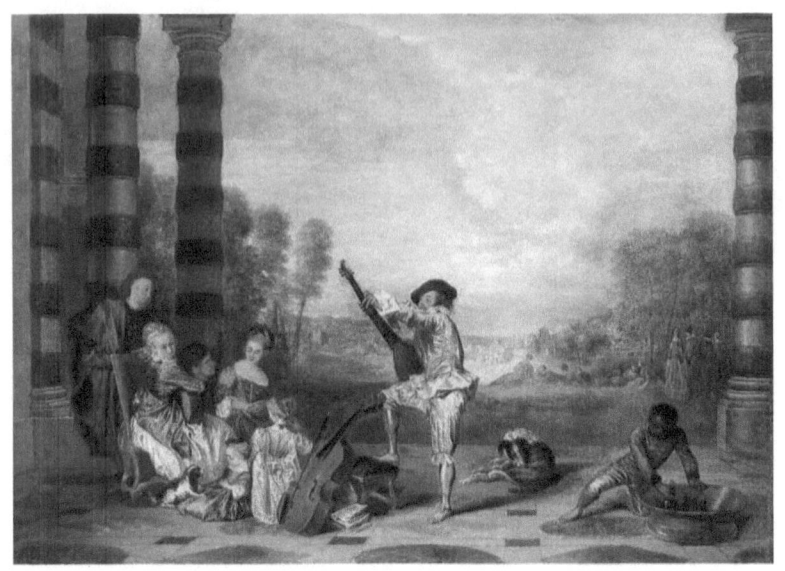

Les Charmes de la Vie (The Music Party)
c. 1718, Oil on canvas, 67 x 93 cm
The most satisfactory version of a composition on which Watteau worked for several years, expressing delicate human relationships through an analogy with music.

Antoine Watteau

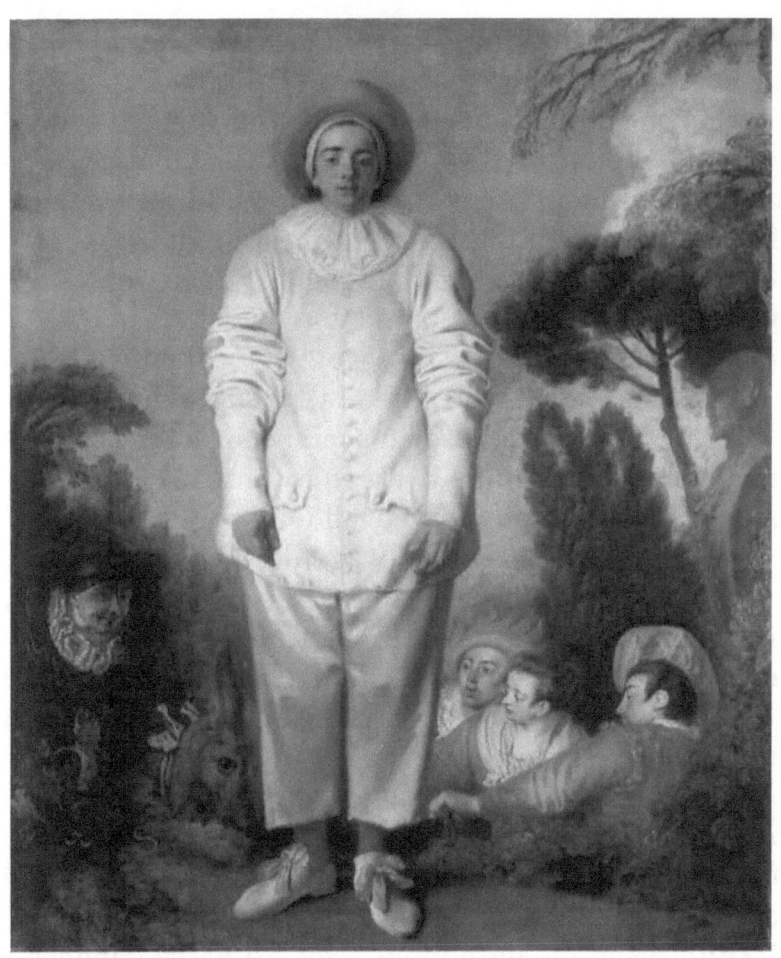

Gilles
1718-20, Oil on canvas, 184,5 x 149,5 cm

The late pictures shows Watteau moving beyond the enchanted mythology of Cythera - not into deeper dreams but closer to disenchanted reality. After a few quite small pictures it was on a large scale that he summed up the sense of isolation and odd man out, in the Gilles. Though this is no self-portrait, the sense of self identification is very strong and adds to the poignant effect. The group of laughing actors in the background, with a clown tugged along Silenus-like on a donkey, is probably inspired by an engraving of Gillot's; but what had been his main subject is deliberately reduced by Watteau to a frieze of busts that do not interfere with the tall white figure of Gilles, perfectly still, posed frontally against the empty sky. Once again, a figure seems to assume clothes for a part. Just as in the Fête vũnitienne Watteau's own sensitive features and beautifully articulated hands contrasted with his humble costume, so Gilles seems too dignified for the clown's white floppy tunic and abbreviated trousers. The moon-shaped hat encircles a vividly painted but solemn face, its lack of animation the more marked when compared with the boisterous lively faces behind. There is a complete separation between the group and the individual; they are active while he is idle, having fun while he remains unsmiling, welded into a self contained group while he gazes out directly at the spectator. It is difficult not to feel that Watteau intends his to be the real awareness. The picture's mood is complex and inexplicably moving; it seems to record not a prologue but an epilogue (as so often in Watteau), a silencing of laughter and the sort of hush that pricks the eyes with unshed tears.

Antoine Watteau

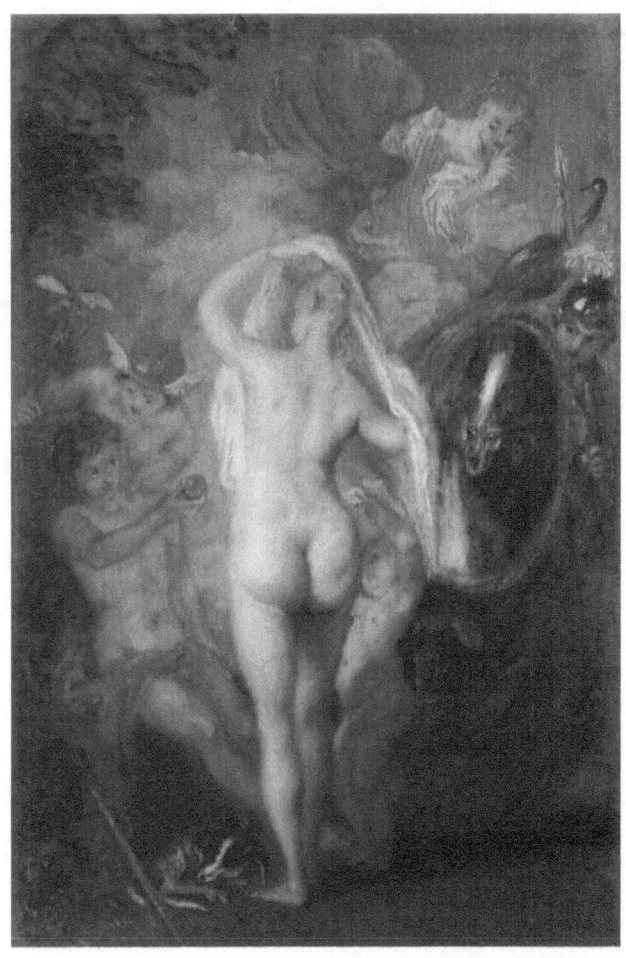

The Judgment of Paris
1718-21, Oil on wood, 47 x 31 cm
The Judgment of Paris (the son of a Trojan king, Priam) is the most popular of all mythological themes in art. The scene depicts the story of his award of the golden apple to Venus in a contest of beauty between her, Juno, and Minerva.

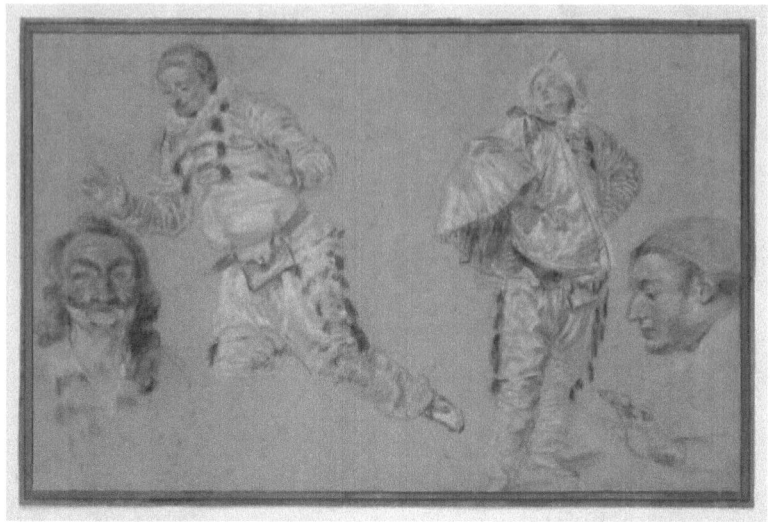

Italian Comedians
1719, Red, black, and white chalks, with stumping, on cream laid paper, 261 x 403 mm Art Institute of Chicago

Antoine Watteau

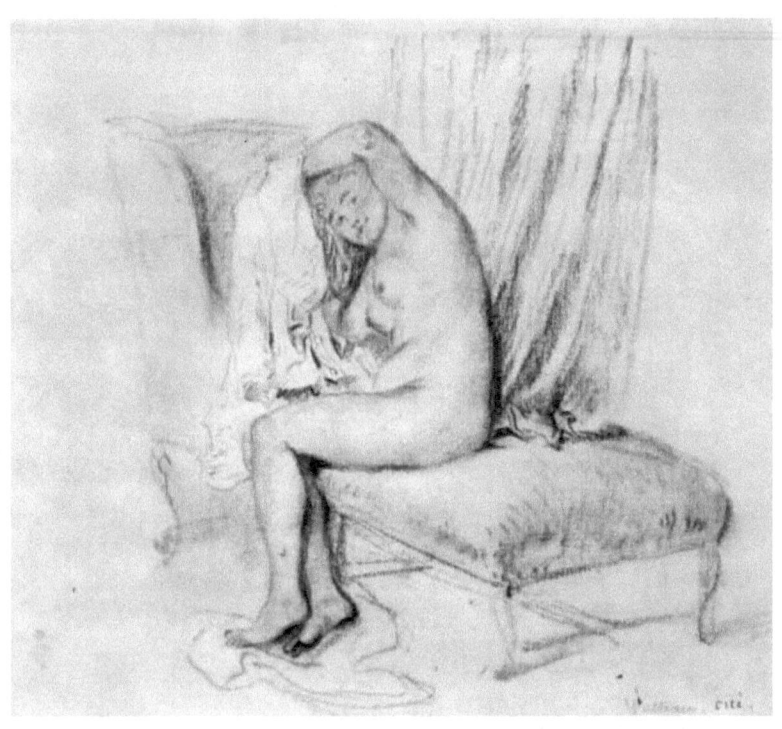

Female Nude on Sofa
1719, sanguine and black chalk, on light blue-gray paper, 22.5 × 25,4 cm, The British Museum, London

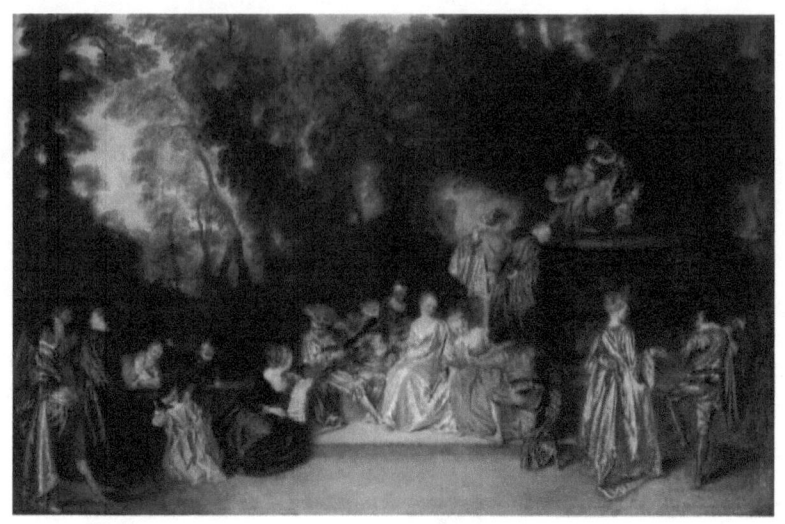

Party in the Open Air
1718-20
Oil on canvas, 111 x 163 cm
In this unfinished painting, lovers in various degrees of engagement are in a park whose Baroque statuary group - an elaborate marble showing putti clambering about a goat - symbolizes passion's exigency. While the dance of love animates this canvas, its completion was stayed by that of death.

Antoine Watteau

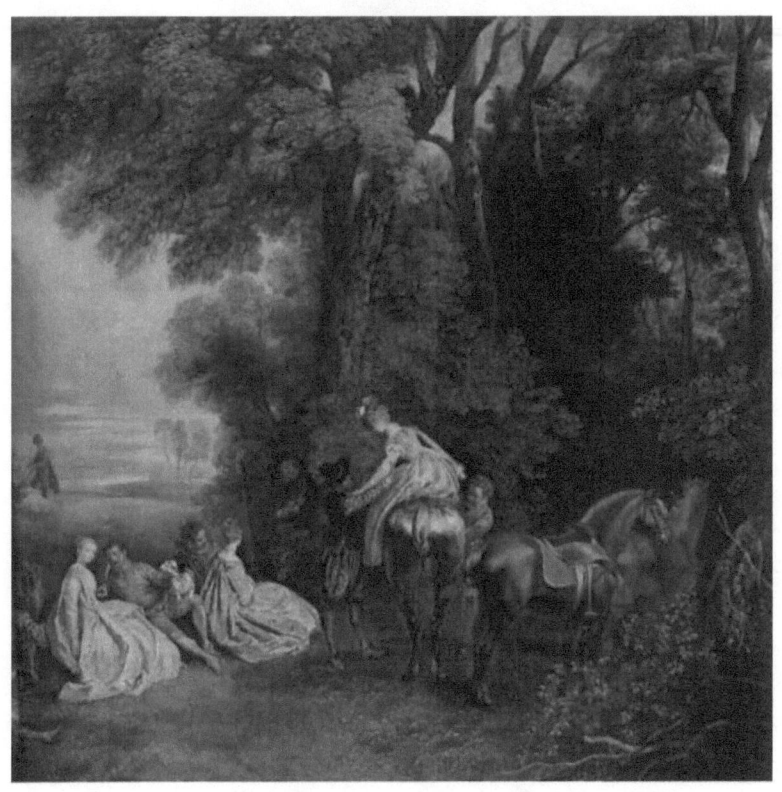

A Halt during the Chase
1720, Oil on canvas

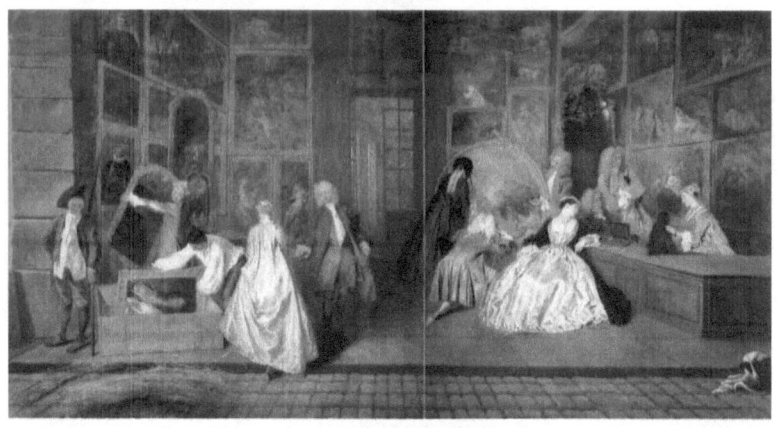

L'Enseigne de Gersaint
1720, Oil on canvas, 163 x 306 cm

By itself, Watteau's Gilles reveals how far Watteau had cut his style off from the rococo decorators. He continued in pursuit not so much of natural appearances as of human nature. Of course, he understood that the two can go together; and he was to bring them together in one final, supreme, and large-scale treatment, self-commissioned: L'Enseigne de Gersaint.

Antoine Watteau

Although nothing so marvellous could have been foreseen, the creation of this picture is logical. It is Watteau's testimony, made solemn by the circumstances, to his passionate attachment to visible things and people. In his own way he had always been a painter of genre. Beneath the airiest of his pictures there lies the scaffolding of his superb drawings, themselves a body of evidence testifying to his vigorous grasp on the hard shell of facts. We, our place in ordinary life - and in the scheme of things: these were the subjects of interest to the eighteenth century. Watteau, reluctant to make any moral judgment, any metaphysical statement, created instead this view of people in a recognizable environment, in Paris, in the shop of his friend Gersaint. Their aims are still the same as they always were in Watteau's pictures; only this time it is love in a shop instead of a garden, and buying and selling now take the place of music in society.

Because quite early (around 1744) it left France for Frederick the Great's collection at Berlin, the picture was not there to help Diderot, for instance, to comprehend Watteau's art. But it may well have influenced the young Chardin, very different though it is from anything he produced. It is a key document, as well as a masterpiece, in which almost every eighteenth-century artistic interest is contained - except the moral one. It is decoration, and trompe-l'oeil decoration, intended for the front of Gersaint's shop - probably for that reason composed, as well as cut, in two halves; not only does it give the illusion of dissolving the shop wall, so that one steps directly in from the street, but the illusion is itself witty: expanding the poky reality of a shop on the Pont Notre-Dame to this grandiose room, with its glimpse of a tall-windowed salon beyond, papered with pictures that Gersaint probably never owned. Thus, though it is genre, it is enchanted genre, animated not only by wit but by a ubiquitous eroticism no longer conveyed through the presence of cupids. It is the paint itself which communicates an almost feverish excitement, a hectic vitality, to the society assembled here in autumn colours, chrysanthemum tones of bronze and yellow and pink, set off by black and silver-grey.

Antoine Watteau

These figures are no longer in fancy dress but in fashionable costume, painted with ravishing response not only to lace and silken textures but to plain linen too - like the pierrot-style shirt of the man handling the portrait of Louis XIV. There are no subsidiary groups on a small scale; all the figures have equal importance in the dance-like rhythm which undulates in and out across the composition, with a convenient pause at the centre. The spectator is invited into the picture by the girl who steps from the street into the shops; her ankle breaks the long horizontal where the two meet and her stocking is revealed as a surprising sage green. As she advances, her partner gallantly steps forward as if in a minuet. They are the last of Watteau's couples, brushed by an invisible amorous genius present in Gersaint's shop - more obviously present in some of the pictures on the walls and quite patently in the large Baignade being examined so closely by the kneeling man who has got down to thigh level. In the group who examine a mirror held by the pretty serving-girl there is more ambiguity: the men examine her as well as the mirror, and the mirror reflects back the image of the beautifully-dressed woman customer who gazes somewhat sadly at it. There is nothing so concrete as a story, but all these people seem looking for more than works of art; and the picture becomes concerned with the shop of the human heart.

The tantalizing sense of psychological realism, perhaps present from the first in Watteau's work, is seen here on a quite new scale. There could be no advance beyond it, because Watteau was to die the year after it was painted, dying in the arms of Gersaint. The intensity behind the Enseigne de Gersaint comes from life looked at in a way it can be looked at perhaps only by the artist and the dying; and Watteau was both. The world of Rubens, which had allured him so much, is rivalled here, in scale and handling, and paid to a last homage in the curled-up dog which comes from the Coronation of Marie de Médicis. This is the real triumph of 'Rubénisme'; out of homage and emulation has come a quite new art.

Antoine Watteau

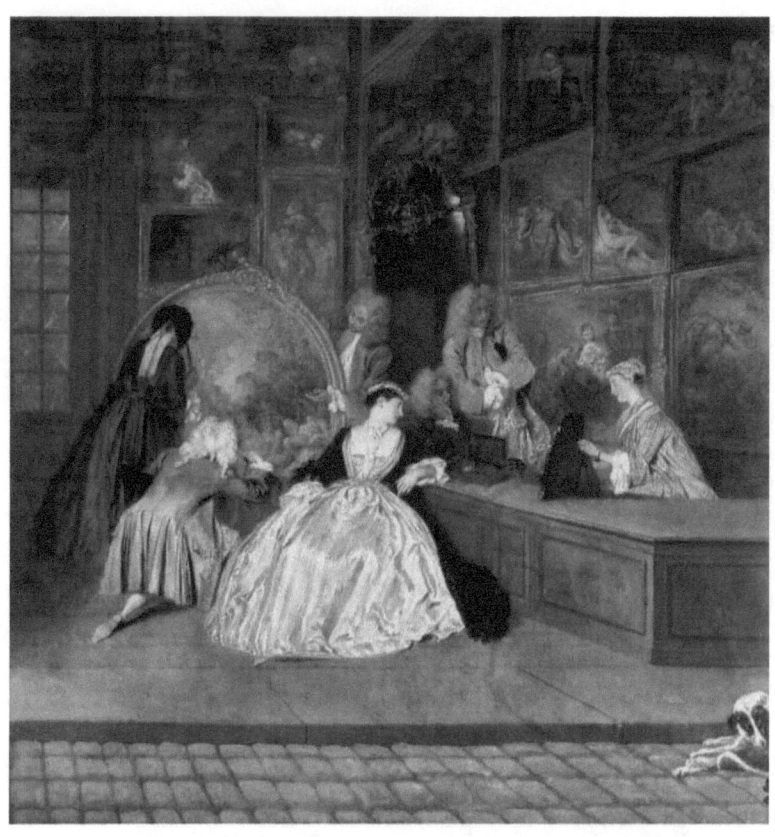

L'Enseigne de Gersaint (fragment)

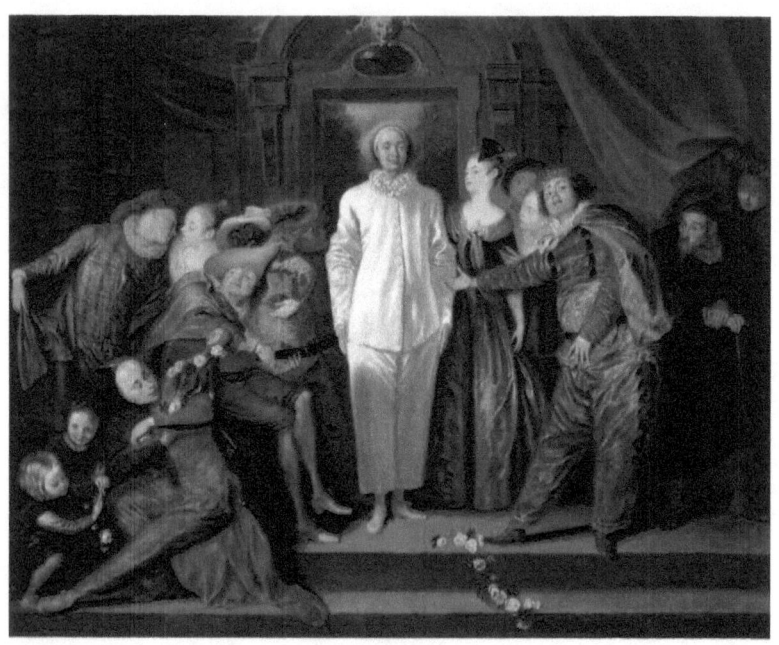

Italian Comedians
c. 1720, Oil on canvas, 64 x 76 cm

One of the most famous of Watteau's paintings, this scenes portrays a troupe of Italian actors, who improvised satirical skits in Paris, lined up as if for a curtain call. The personalities of these players were stock characterizations; the figure in the centre is Pierrot, who was cast as the amiable yet unsuccessful lover who was constantly ridiculed. Despite the animated gestures and flickering light, a certain tender pathos pervades the scenes. One of Watteau's last works, painted shortly before his death at the age of thirty-seven, this canvas was supposedly given to his English doctor in payment of a medical fee.

Antoine Watteau

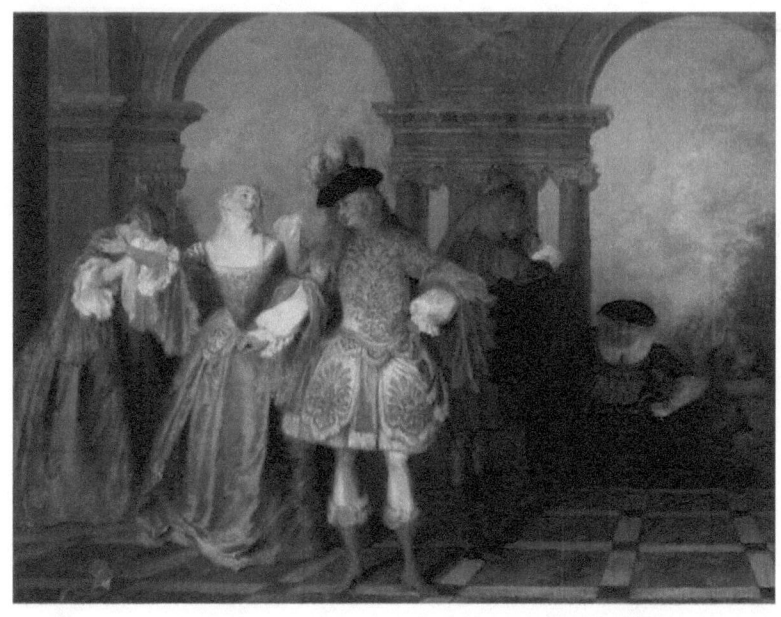

Actors from the Comedie Francaise
c. 1720, Oil on canvas, 57 x 73 cm

Until the end of the seventeenth century the theater of the great tragic playwrights and of Moliиre inspired painters little or not at all, apart from illustrated editions. Change occurred when Claude Gillot and his pupil Antoine Watteau drew a great deal on 'commedia del'arte' characters, which had been familiar to the French public for a century, though mainly on a burlesque level. The Italian Commedia dell'Arte troupe, which had been banned in 1697, was reestablished in 1716. Watteau's Actors from the Comйdie Franзaise, a light, silvery canvas, gives an idea of their theatrical costumes and gestures.

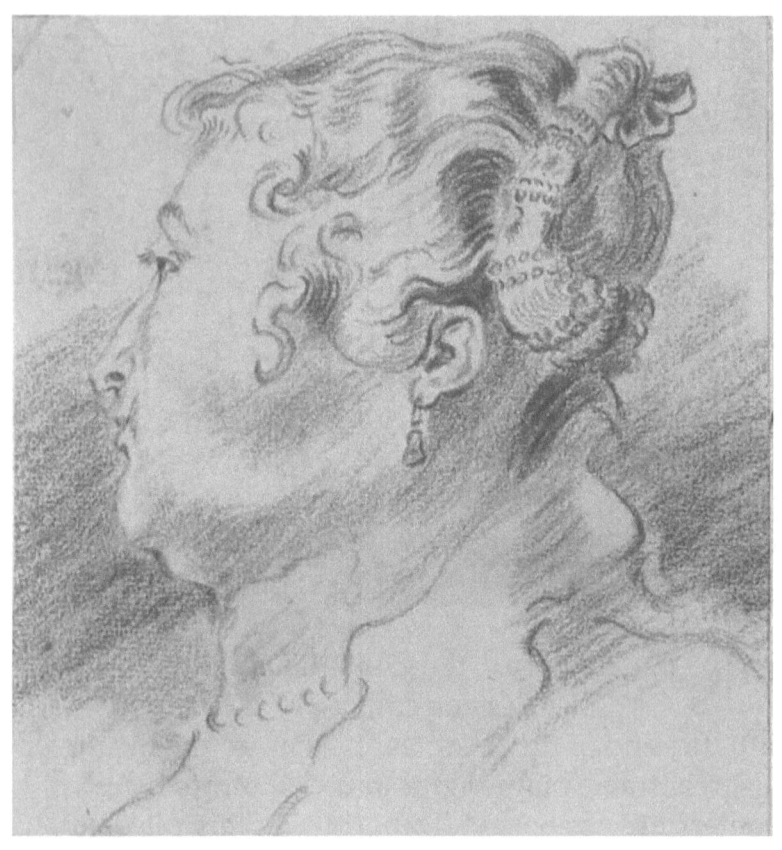

Study of Woman's Head
1720-30, Red chalk on paper, Cooper-Hewitt, National Design Museum

Antoine Watteau

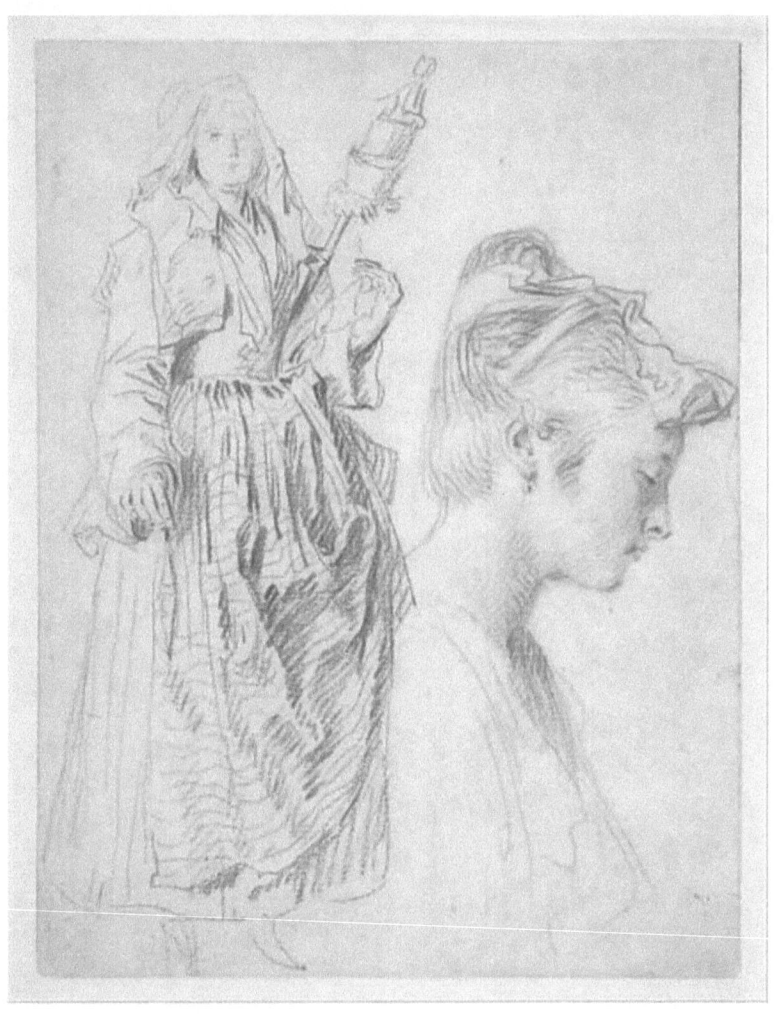

Standing Woman Holding a Spindle, and Head of a Woman in Profile to Right
n.d., Two shades of red chalk, 16.4 x 12.2 cm, The Metropolitan Museum of Art

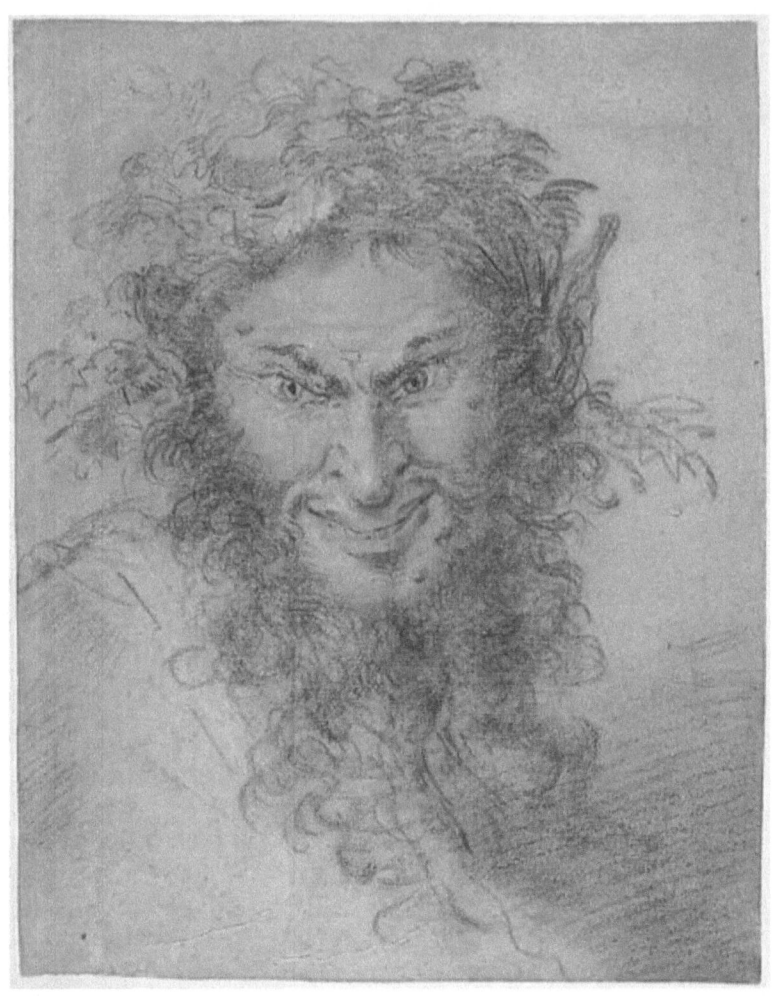

Head of a Satyr
n.d., Black and red chalk, heightened with yellow chalk with traces of white chalk on brown paper, 32.7 x 24.9 cm, The Metropolitan Museum of Art

Antoine Watteau

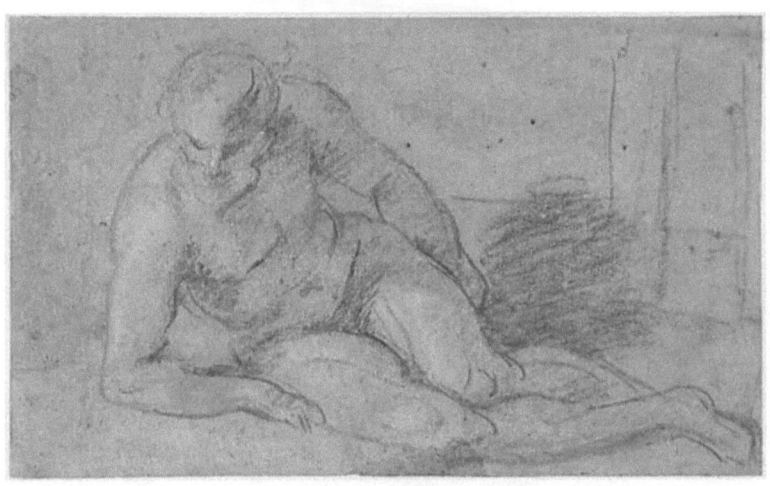

Reclining Nude Figure
n.d., Red, black and white chalks, 13.5 x 22 cm, The Metropolitan Museum of Art

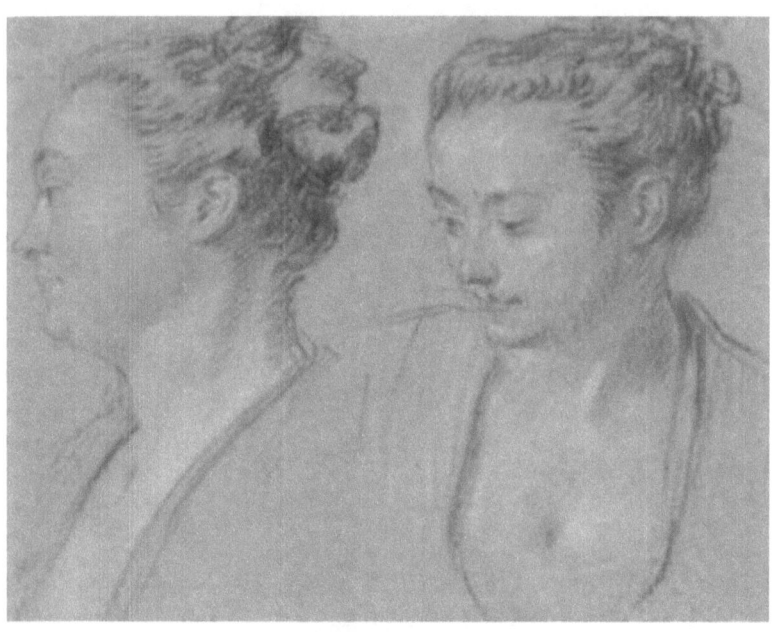

Two heads of women
n.d., Red, black and white chalk on brown paper, 13 x 16.5 cm, Private Collection

Among the facets of Watteau's work most admired by his contemporaries were these studies representing ravishing women's heads, in elegant feminine attitudes, sometimes presented alongside masculine faces.
The position of the heads, some livelier than others and different in every new composition, imbues these drawings with continually-renewed dynamism.
The head at the left of the present drawing was engraved in reverse by François-Bernard Lépicié. This work included more than three hundred plates engraved after Watteau's drawings.

Antoine Watteau

The model is probably the same as that who appears on the famous sheet in the Louvre, Huit études d'une tête de femme et une tête d'homme: the second head on the upper left of that sheet, closely resembles the woman on the left of this drawing.

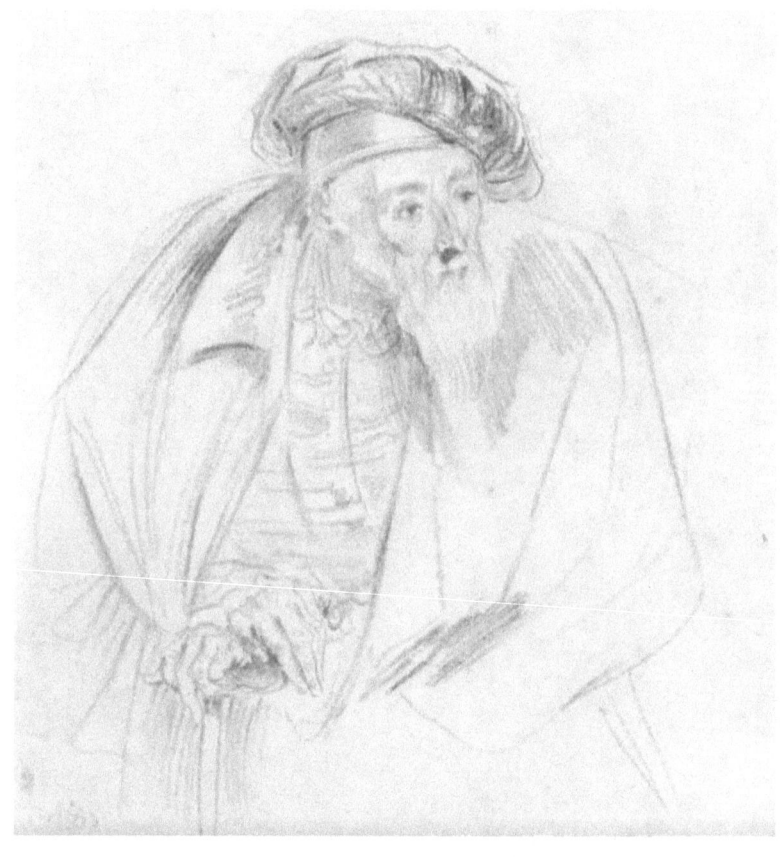

Study for the Bearded Doctor in Les
n.d., Red and black chalk, 256 by 206 mm, Private Collection

Jessica Findley

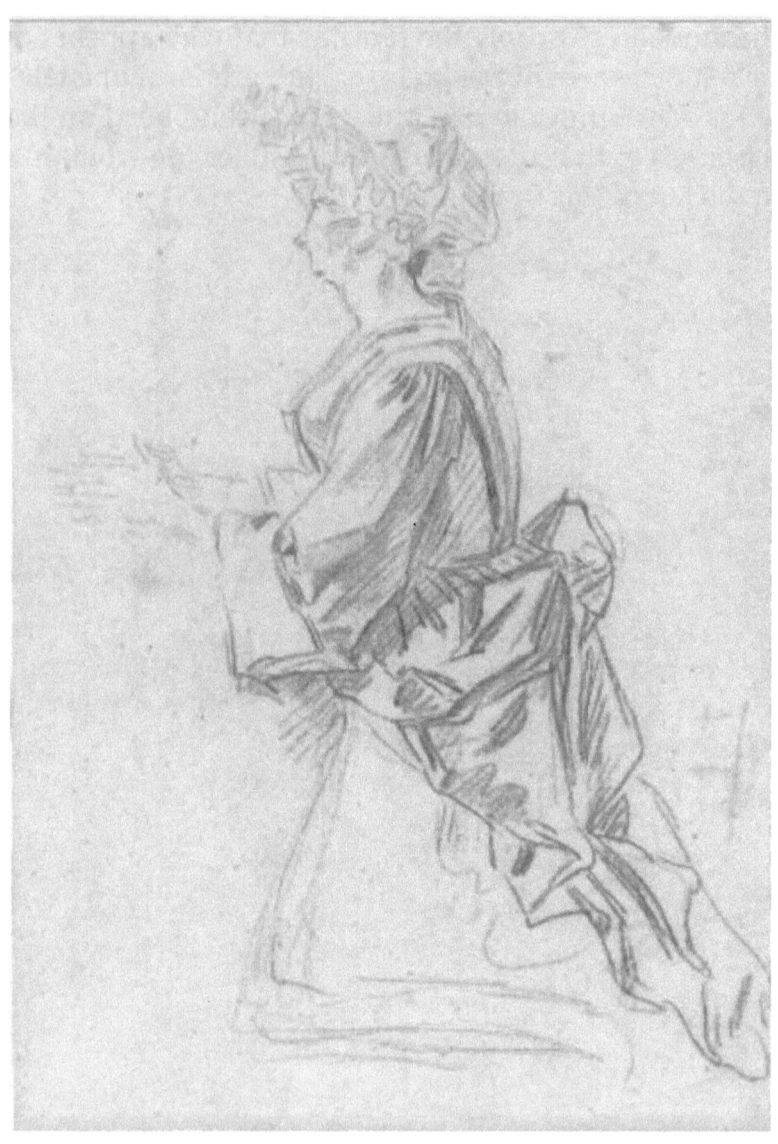

A kneeling woman praying, seen from the side
n.d., Red chalk, 353 x 237 mm, Private Collection

Antoine Watteau

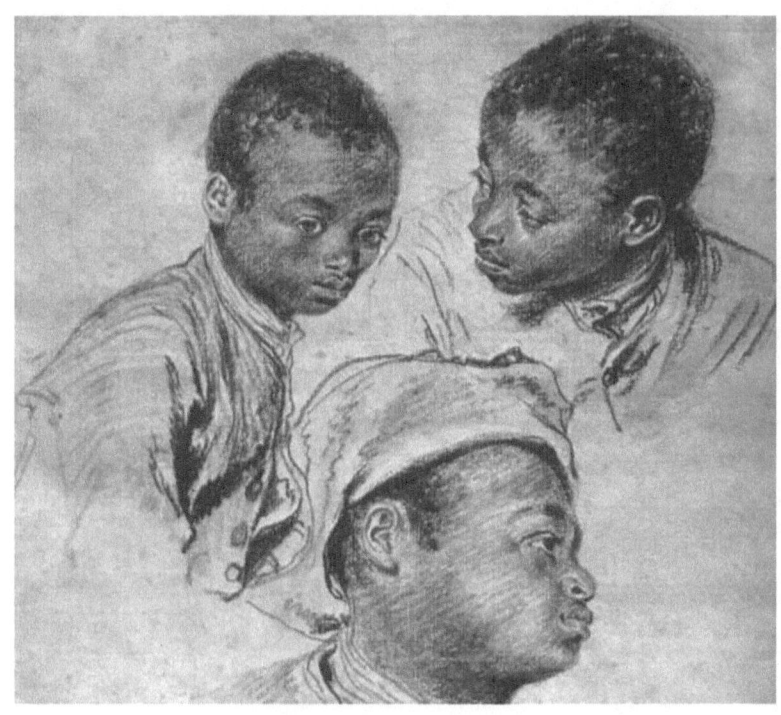

Three studies of a boy
n.d., Coloured chalks, Musee du Louvre

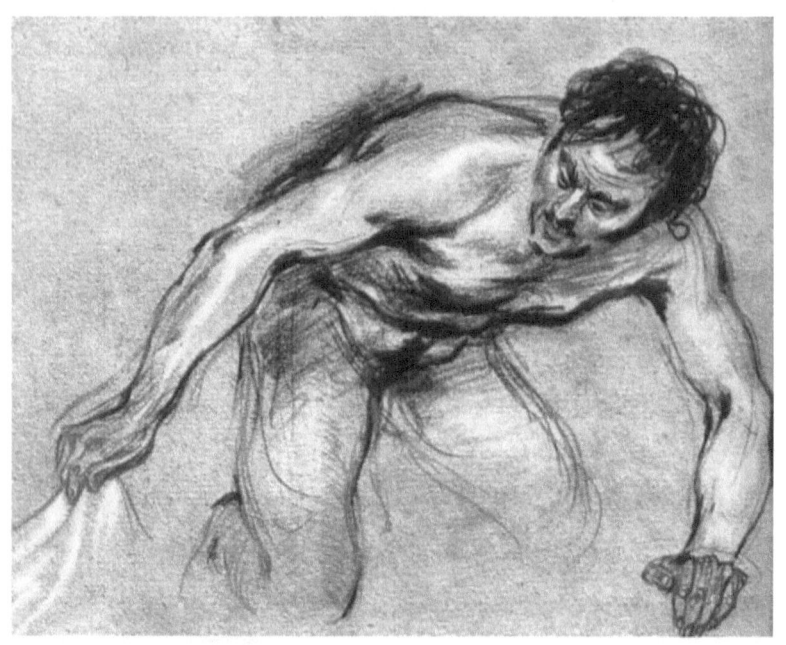

Kneeling Male Nude
n.d., Coloured chalks, Musee du Louvre

Antoine Watteau

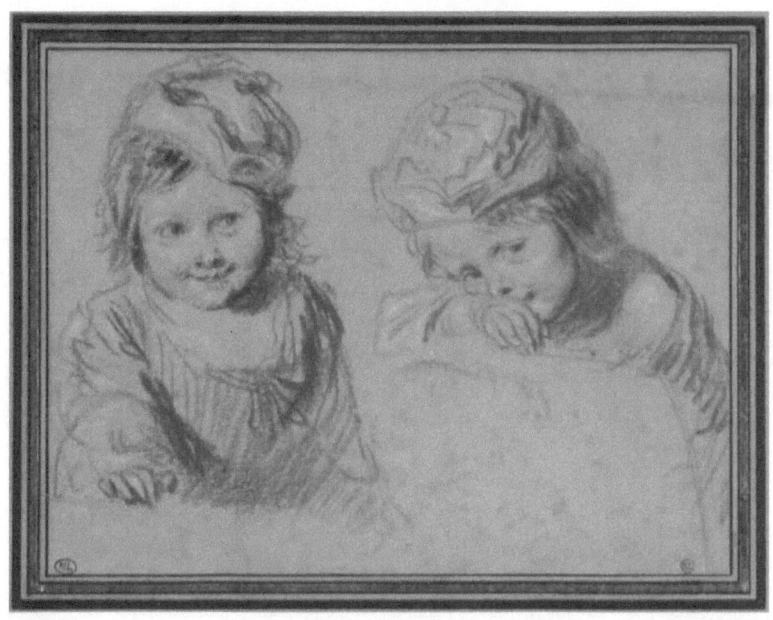

Two studies of a child, seen from the waist up and
wearing a toque
n.d., Coloured chalks, Musee du Louvre

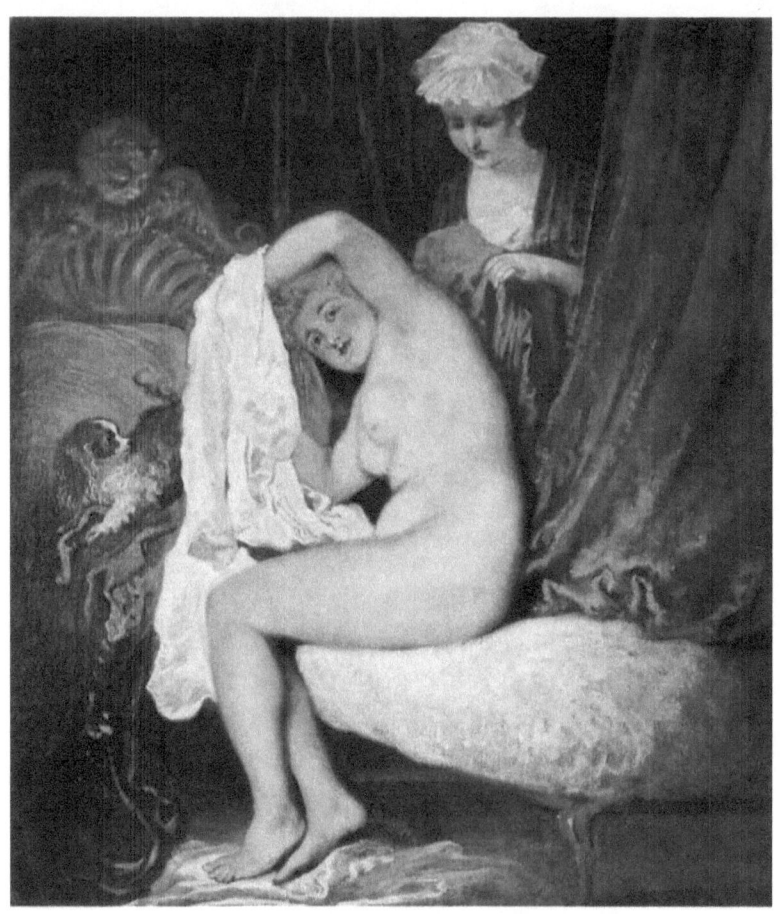

The Toilette
n.d, Oil on canvas

Antoine Watteau

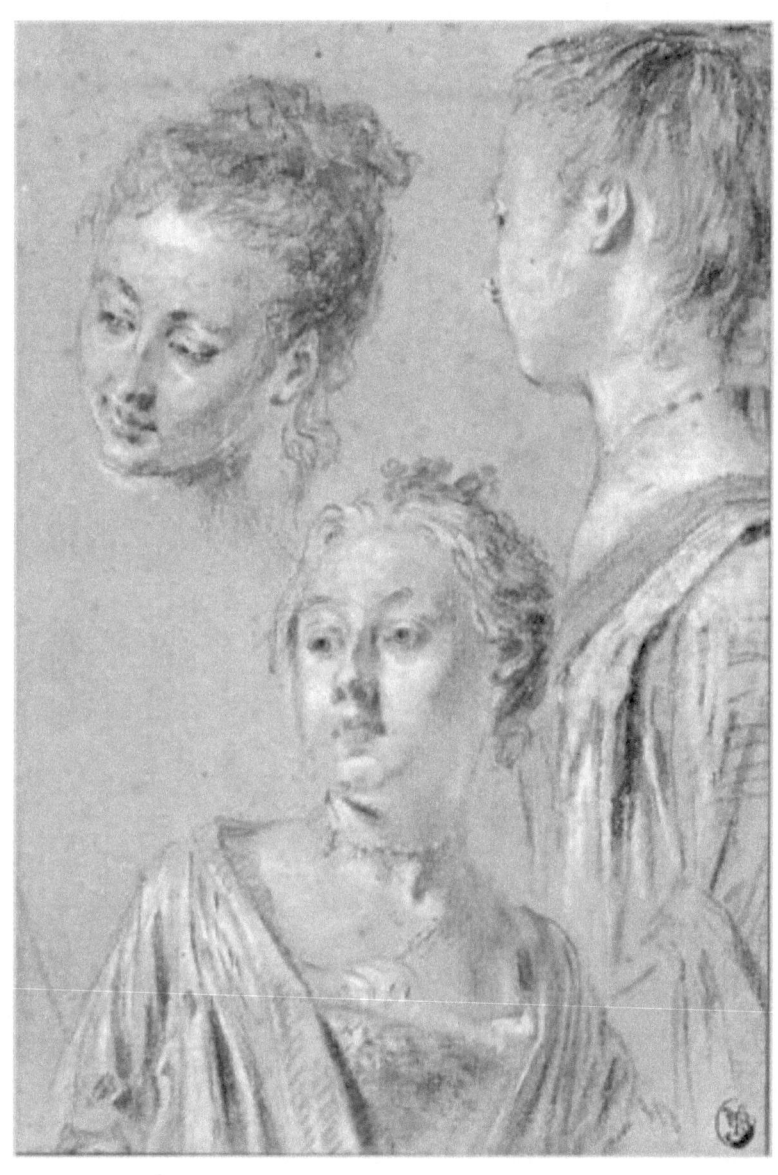

Study of heads
n.d., Chalk drawing

Jessica Findley

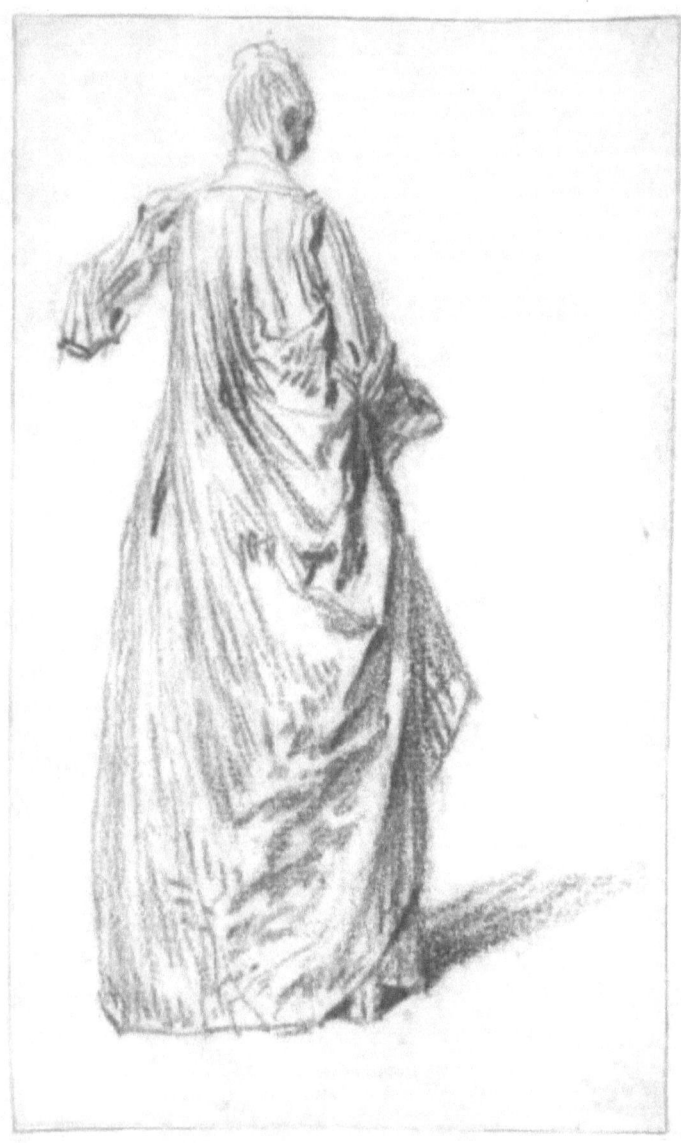

A lady, seen from behind
n.d., sanguine chalk and traces of black chalk on paper,
136 x 80 mm, The Fitzwilliam Museum, Cambridge

Antoine Watteau

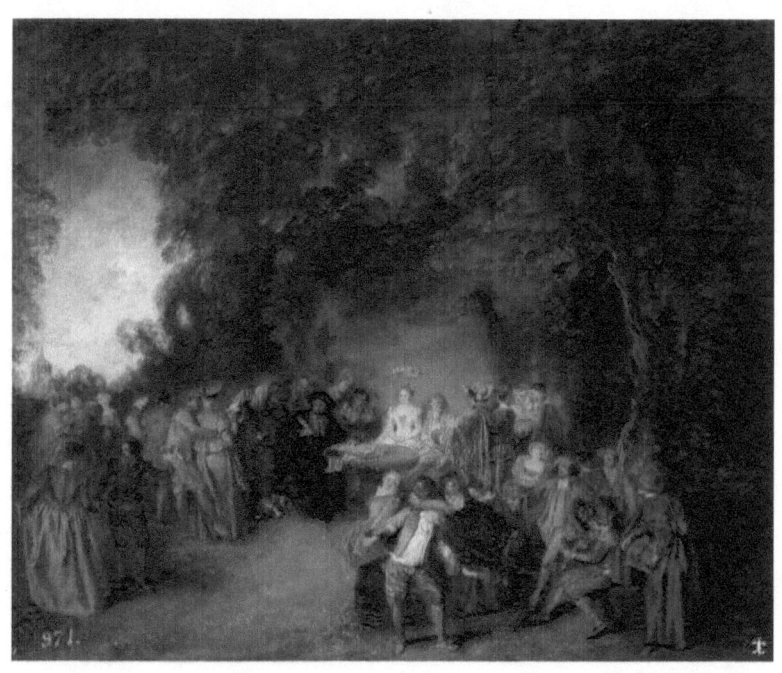

The Marriage Contract
n.d., Oil on canvas, 47 x 55 cm

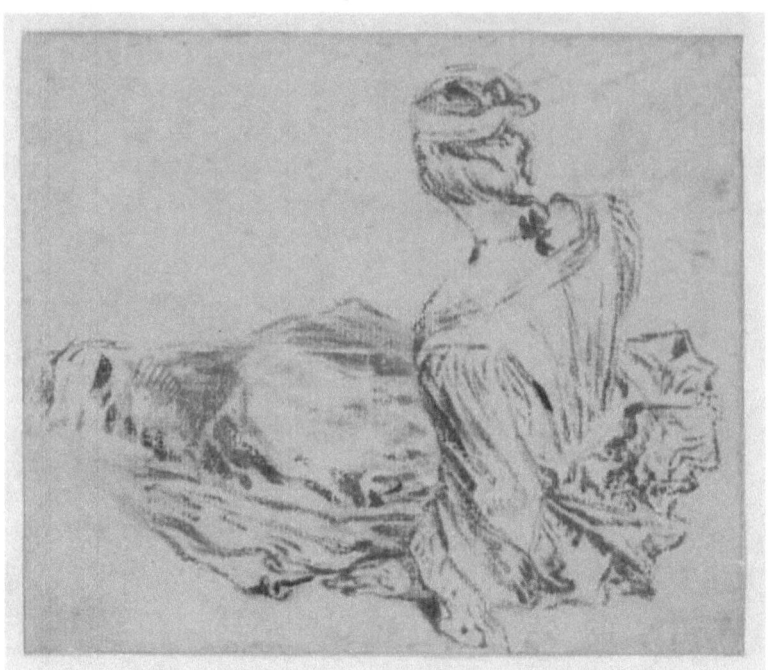

Reclining lady seen from behind
n.d., contre-épreuve (offset) in sepia on paper, 115 x 133 mm, The Fitzwilliam Museum, University of Cambridge

www.ingramcontent.com/pod-product-compliance
Lightning Source LLC
Chambersburg PA
CBHW020920180526
45163CB00007B/2814